D1452242

Number Six: The Joe and Betty Moore Texas Art Series

Pecos to Rio Grande: *Interpretations of*
Far West Texas by Eighteen Artists

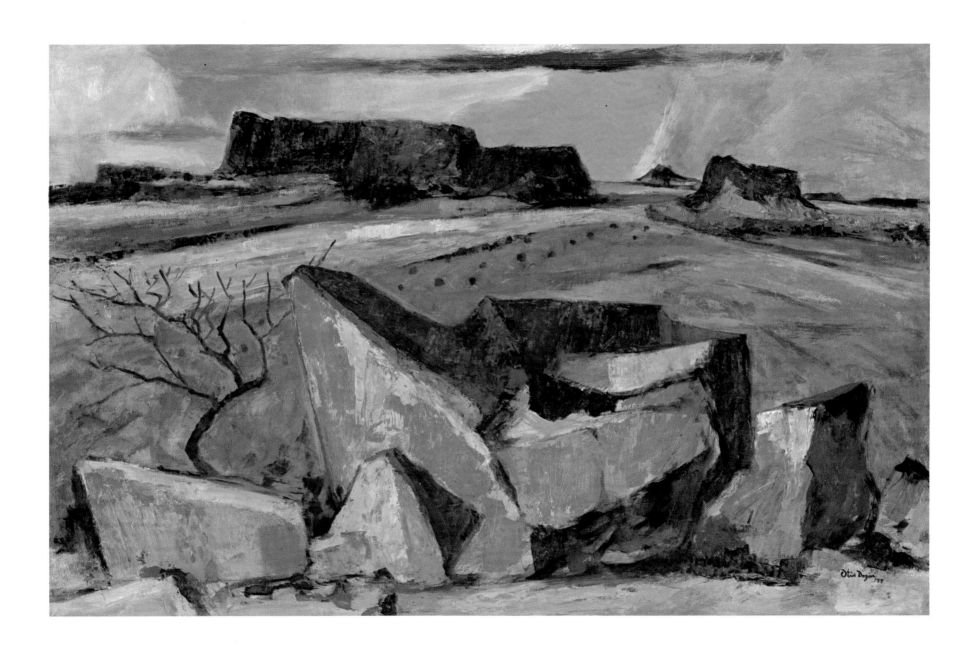

Pecos to Rio Grande

Interpretations of Far West Texas by Eighteen Artists

Introduction by RON TYLER
Publisher's Foreword by FRANK H. WARDLAW

Paintings by

AL BROUILLETTE

MARBURY HILL BROWN

JERRY BYWATERS

FINIS F. COLLINS

OTIS DOZIER

HEATHER EDWARDS

MICHAEL FRARY

FRANK GERVASI

JOHN GUERIN

WILLIAM HOEY

DeFORREST JUDD

WILLIAM LESTER

IVAN McDOUGAL

CLAY McGAUGHY

ANCEL E. NUNN

STEPHEN RASCOE

EVERETT SPRUCE

E. GORDON WEST

TEXAS A&M UNIVERSITY PRESS
College Station

Library of Congress Cataloging in Publication Data
Main entry under title:

Pecos to Rio Grande.

(The Joe and Betty Moore Texas art series; no. 6)
"Paintings by Al Brouillette, Marbury Hill Brown, Jerry
Bywaters, Finis F. Collins, Otis Dozier, Heather Edwards,
Michael Frary, Frank Gervasi, John Guerin, William Hoey,
DeForrest Judd, William Lester, Ivan McDougal, Clay Mc-
Gaughy, Ancel E. Nunn, Stephen T. Rascoe, Everett Spruce,
E. Gordon West."
 1. Painting, American—Texas. 2. Painting, Modern—
20th century—Texas. 3. Texas in art. I. Brouillette, Al.
II. Series.
ND230.T4P38 1983 758'.1'09730740164242 83-45105
ISBN 0-89096-166-2

Photographic credits:
Jerry Bywaters, *Terlingua Graveyard*. Photo by Douglas Winship. Frank Gervasi,
Alpine Hills. Photo by Jim Bones, Jr. Frank Gervasi, *Shafter—A Quicksilver Mining
Town*. Photo by Jim Bones, Jr. Frank Gervasi, *Twin Peaks*. Photo by Jim Bones, Jr.
William Lester, *Old Fort Davis*. Photo by David Wharton. William Lester, *Three
Peaks*. Photo by David Wharton. Stephen Rascoe, *Aerial View of Canyon Country
with Clouds*. Photo by Sherry Dunaway. Stephen Rascoe, *Blue Rain over Canyon*.
Photo by Sherry Dunaway. Stephen Rascoe, *Iron Bridge over Creek*. Photo by
Sherry Dunaway.

Manufactured in the United States of America
FIRST EDITION

This book is dedicated to the memory of
Jack K. Williams
1920–81

Contents

Publisher's Foreword

By Frank H. Wardlaw, Director Emeritus

It is particularly appropriate that both the Texas A&M University Press and the sponsors of the Joe and Betty Moore Texas Art Series have agreed that this book should be dedicated to the memory of Jack K. Williams since it is probable that neither the Press nor the Moore Series would have come into existence without his far-sighted vision. Since I had a hand in the beginning both of the Press and of the series the present director of the Press has asked me to contribute a personal foreword. It could not be other than personal because of my deep respect and affection for Jack Williams and Joe and Betty Moore.

In the autumn of 1973 I was in the middle of my twenty-fourth year as director of the University of Texas Press. My friend John Lindsey of Houston and I were in the kitchen of his home at Galveston Beach, combining the usual pre-prandial activities with a discussion of university presses. John is a devout Aggie (Jack Williams once said that he stayed awake nights thinking of things he could do for A&M). He asked me if I thought A&M should start a press and, if so, if I would be interested in directing it. I told him that there had never been a more difficult time to begin such an enterprise and that it could not possibly be successful without the solid backing of the University—the administration, the regents, the faculty, and the alumni. The idea of starting a new press with that kind of backing, I said, rather appealed to me because it would be fun to begin again at the age of sixty and try to avoid at least some of the mistakes I had made in the past. Afterward I more or less dismissed the conversation from my mind; I really had no intention of leaving the University of Texas.

Several weeks later Jack Williams, the president of A&M, called me and asked me to meet him for breakfast in Austin. I had met him before and knew his reputation but did not really know him. He told me that John Lindsey had told him of our beachhouse conversation and that he was interested in pursuing the matter further. In the next two hours we discussed exhaustively the problem of starting a new press. He had an extraordinarily quick mind and readily grasped the challenges, difficulties, and complexities of scholarly publishing as I saw them from the vantage point of thirty years' experience in the field. I did not minimize the problems. As our conversation ended he asked me to write a letter setting forth the conditions—organizational, financial, and otherwise—under which I would consider coming to A&M. He asked me to describe the kind of program I thought would be successful at A&M. After careful thought I wrote the letter he had requested. He answered quickly, agreeing in principle to all the conditions laid down in my letter and asking my wife, Rosemary, and me to come to College Station to examine the situation firsthand.

We came to Aggieland and liked what we saw, a university with dynamic leadership and obviously high morale among the faculty, students, and alumni. We talked with the business people (it makes it very difficult for a press if their attitude is obstructionist), with the officials of the Development Office and the Association of Former Students, with the purchasing and personnel offices, and with a number of the leading academic administrators. I decided that it really would be a happy challenge to begin a new press under such circumstances. A second trip and the die was cast. The Regents (then called directors) accepted Jack Wil-

liams' recommendation that a press be established in accordance with the conditions on which we had agreed, and the necessary funds were provided. A happy addition was made: the lovely old Board of Directors House, then slated for destruction, was turned over to the Press as its headquarters, and Rosemary and I were granted permission to live in the apartment downstairs. And so, in August, 1974, we made the long move from Austin to College Station and began to operate.

I had told Jack Williams that I wanted to recruit a small but highly professional staff and he made it possible for me to get exactly the people I wanted. I was even eventually able to suggest my successor and bring him in as associate director a year before my retirement. Perhaps the most important and long-lasting contribution I made to the Press was the selection of the staff.

Every promise that had been made to me was scrupulously kept. I soon found that I had realized a scholarly publisher's dream: I was directing a press with the enthusiastic backing of the entire university. Universities are not basically organized to operate publishing programs, and a number of standard regulations had to be modified and much red tape cut to enable the Press to do its job. The Development Office and the Former Students Association became actively involved in raising funds for the Press for special series of books. In all these things Jack Williams played an active role. I was given as free a hand in developing the program as any director possibly could have desired. In the thirty-eight years I have spent in academic life I have never served under a president who combined pragmatic idealism, imagination, and administrative ability to the extent that Jack Williams did.

Our Faculty Advisory Committee was a joy to work with. It was headed by Haskell Monroe, dean of faculties, who had worked with me for several months before the Press actually came into existence, solving various organizational problems. The Press owes a deep debt of gratitude to Monroe, now president of the University of Texas at El Paso.

It would require entirely too much space for me to mention the many ways in which Jack Williams helped the Press. As an example I will tell you how the Joe and Betty Moore Texas Art Series came into existence.

It all started with a letter from my friend the late Mitchell A. Wilder, director of the Amon Carter Museum of Western Art in Fort Worth. A young man from Sweetwater, Mondel Rogers, had showed him a portfolio of photographic prints of a series of paintings which he had made of old ranches of the Texas Plains. Mitch thought they were good and that I should see them. I wrote to Rogers and he sent his portfolio of prints of his paintings, mostly egg tempera and dry-brush watercolor. We were impressed by them and knew immediately that we wanted to make a book of them. For some time I had contemplated the development of a series of Texas art books, but a large amount of capital would be required and we didn't have it. I showed the pictures to Jack Williams, told him I thought Mondel Rogers' book would make an ideal beginning for a Texas art series, and asked his advice concerning prospective donors of a revolving fund for the publication of such a series. This was in the autumn of 1974. We were just beginning work on our first list of books, which would appear the following fall.

Several weeks later Jack Williams asked me to accompany him and several other people on a trip by plane to Amarillo and Midland, where the Association of Former Students had planned meetings of local alumni. He told me to bring the Mondel Rogers portfolio with me. First we showed it to a devoted Amarillo alumnus who had been generous in his support of many university causes. He liked the pictures but was unable at the time to help us.

As our plane landed in Midland Jack told me to bring the portfolio with me to the motel where the meeting was to be held. He said that his dear friends Joe and Betty Moore, tireless and generous supporters of the university, would be there and he wanted them to see the pictures.

Before the dinner we had drinks with Joe and Betty Moore in their room, which adjoined ours. Jack told them about the Rogers pictures, and I discussed my idea for a Texas art series. I also disclosed how much it would cost. They expressed a desire to

see the portfolio and I brought it in. They examined it carefully and Betty sat on the edge of the bed and went through it several times. When we left to go to dinner, Betty asked if she could keep the portfolio a little longer.

When our plane left late that night for College Station, I still didn't know the extent of the Moores' interest.

I like to think of it as an omen. On the flight back Jack Williams was playing gin rummy with Tom Nelson (Aggie style, with aces both high and low). Tom dealt him a pat hand. He ginned without drawing a card.

Three days later Joe Moore phoned Bob Walker, vice president for development, and told him that he and Betty had decided to back the series. They liked the Rogers pictures and liked the idea of the series, but the principal reason they decided to make this substantial gift, Joe said later, was "because Jack Williams wanted us to."

In the years which have passed since then five other beautiful books have been published in the Joe and Betty Moore Texas Art Series: *Impressions of the Texas Panhandle*, by Michael Frary; *Buck Schiwetz' Memories*, by E. M. Schiwetz; *The Texas Gulf Coast: Interpretations by Eight Artists*; *The Texas Hill Country: Interpretations by Thirteen Artists*, and now the book which you hold in your hands.

The Moores have helped the Press in many other ways and have become firm and beloved members of the Press family. Their services to the university have been too numerous to recount. A good example is their splendid restoration of the remarkable old Hirshfeld House in Austin, which will serve A&M in many ways through the years.

Joe and Betty Moore, who loved Jack Williams and whose devotion to his memory has never wavered, share his quality of pragmatic idealism.

I wish it were possible to mention the many other people who contributed to the success of the Press in its beginning years, but space does not permit. Frank W. R. Hubert, who succeeded Jack Williams as chancellor of the University System, picked up where Williams left off in his interest in and support of the Press. And the Board of Regents, supportive at all times, made what would seem to be a permanent commitment to the Press when they authorized the construction of the fine new building into which it has just moved, a replacement for the old Board of Directors building, which was destroyed by fire in 1979. But this personal preface is concerned primarily with Jack Williams, that remarkable man who was principally responsible for making the idea of the Press a reality.

Introduction

"The only way you can get to Van Horn from here," she said, "is to cross the river. There's a dirt road on the Mexican side." As I listened to her flat voice and looked around me at the shelves lined with canned goods and jars and the pine floor that had been swept and oiled until it glowed with the patina of hundreds of polishings, I heaved a deep sigh. Ever since I had reached Alpine the day before, the country had pulled and tugged at me to slow down. I resisted because I had a schedule. But now, in the middle of a small general store in Candelaria, Texas, in the heart of the Big Bend Country, I relaxed to savor the ambience.

Candelaria was a good place to begin. It is a turn-of-the-century village a few miles east of the Rio Grande and about forty miles up the river from Presidio. I was there because an intriguing old photograph of soldiers in pursuit of Pancho Villa, made nearby, had caught my attention years ago when I was working on a book about the Big Bend. I had not gotten to the village as a part of my research then, but the opportunity was coming my way now, in 1979, when a friend at Sul Ross State University in Alpine invited me there to participate in a program. I had not visited this, the last frontier of Texas, since my book appeared, so I eagerly accepted so I could see what changes had taken place.

Like most other West Texans, residents of Alpine rise early, it seems, usually before sunup. The morning after my talk, although I am a late sleeper, I joined them in the motel coffee shop for several minutes of eavesdropping along with scrambled eggs and bacon. Cowboys from the nearby ranches mixed easily with the tourists and traveling salesmen, but I did not feel a part of this casual scene. With my thoughts already drifting toward the nine-teenth century, and further, I decided to take the several hours that I had to spare for a return visit to Big Bend National Park.

Big Bend is one of the remotest and most subtly beautiful domains in the entire park system. It became a national park in 1944, largely through the efforts of former Texas Ranger and sheriff of Brewster County Everett E. Townsend, Amon Carter, Sr., of Fort Worth, and dozens of others who worked through the latter years of the Depression and World War II to acquire land. It was dedicated in 1955, and the park service has emphasized its unusual geology and plants and wildlife ever since. The Big Bend was the world of the naturalist, but I knew its history, which to me was equally apparent and much more exciting.

With the sun high in a clear sky, I headed south down State Highway 118, recognizing each feature of the increasingly familiar terrain as an old friend. I quashed the urge as I neared the park to turn off toward Terlingua, a deserted World War I–era quicksilver mining town that has become home to merchants selling Rio Grande raft trips, camping supplies, and real estate. Terlingua can still cast a spell, but the Mexican cemetery has been vandalized by souvenir hunters—my ten-year-old snapshots show a relatively intact burying ground with several markers reminiscent of the ancient Spanish grave carvings—and some of the empty buildings have been minimally modernized to accommodate the thousands who gathered for the annual chili cook-off, and the town has not been the same since. During my last visit there the change had saddened me considerably. I would not let it intrude on this day.

I drove on, thinking more of those who had first explored

the Big Bend than of the recent arrivals. Cabeza de Vaca, the sixteenth-century Spaniard who artfully maneuvered his way through the Texas Indians into northern Mexico, might have been the first European to see it. The Franciscans followed closely behind, blessing the Jumano Indians, who were on hand to welcome them, and moving quickly on to more hospitable environs. The Anglo-Americans did not arrive for three centuries—not, in fact, until the United States wrested the Southwest from Mexico in 1848.

Finally in the park itself, I stopped at the Painted Desert and marveled again at Mule Ears Peak, its historic name supposedly settled upon by the hundreds of teamsters who hustled their obstinate charges past its twin peaks on the way to and from Mexico. I paid a call at the Park Service headquarters at Panther Junction and made a quick trip up into the Chisos Basin for a closer look at Casa Grande, Emory Peak, and the "window," the V-shaped gap between Amon Carter Peak and Vernon Bailey Peak. The Chisos Mountains are one of the most unusual features of the Big Bend, an alpine environment completely surrounded by the Chihuahuan Desert. Many of the plants and animals of the Chisos are hostages, being unable to survive if they should move only a few miles down to the desert floor. The mountains are an excellent place to look for many of the almost four hundred species of birds that have been reported in the park. Remnants of the old Civilian Conservation Corps barracks, recalling the days when government scientists first began studying this biological island, are still used in the basin. It was in CCC days that the sculptor Gutzon Borglum visited the Big Bend looking for an appropriate mountain on which to carve his monument, before he decided on Mount Rushmore.

Southern Brewster County was still quite isolated in the 1930s. The CCC, and later the park service, built dirt roads and wooden bridges in the park area, but the few ranchers and sheepherders living there had to travel back and forth over poorly graded and badly eroded paths. I had noticed that it is difficult to receive radio or television signals in the park area without a tall and extremely sensitive antenna, but I did not comprehend the remoteness until an old cowboy told me of an experience he had in the early forties. Crossing the parkland near the Chisos Mountains, he had settled his herd of horses near an old sheepherder's camp, so they pooled their resources at supper and spent an hour or so in conversation. The next morning the cowboy had ridden several hundred yards from their common campsite when the old man came running toward him, yelling for him to stop. He had not heard any news for several months and wanted to know if we had declared war on Germany yet.

I would not make it down to Boquillas Canyon, in the southeast corner of the park, on this trip. The longest of the three major Rio Grande canyons and an insurmountable obstacle to the 1852 boundary surveyors, Boquillas shelters the remains of ancient Indian villages that puzzle scientists even today. There is abundant record that prehistoric men lived along the river in sedentary dwellings. They farmed and hunted small animals, and examples of their pottery, baskets, and rock painting now in several museum collections suggest a well-developed society. Suddenly, the Indians left the Big Bend. There are several theories—drought, hostile nomads, disease—but no one really knows why.

There is even a theory—supposedly substantiated by a clay tablet that disintegrated shortly after it was discovered in the 1960s—that European, or perhaps Phoenician, mariners sailed up the Rio Grande as far as the Big Bend, where they left proof of their visit on the clay tablet and hid it in one of Boquillas' many caves. It is a theory that will probably excite little scientific interest unless further evidence is found, but it has led several explorers to search the caves of the canyon during leisurely float trips. I have poked about a bit myself, but any further searching would have to wait for another, lengthier trip.

Nor would I get to see Mariscal, the least accessible of the canyons. Located miles off the paved road near the southern tip of the Big Bend, Mariscal is a beautiful canyon of vertical walls with patches of openness. I was surprised during a recent float to find the remains of a large candelilla wax plant in one of the

draws leading off on the Mexican side. The candelilla plant grows wild in the Big Bend and, with a minimum of processing, yields high-grade, natural wax that is used in making candles, phonograph records, polishes and waxes, and chewing gum. By locating in the canyon, some enterprising wax maker had assured himself a good supply of water for boiling the long, slender candelilla stems as well as a marvelous shelter from the officials of the Bank of Mexico, who regulate the wax production.

It might have been the rugged Mariscal Mountain that turned the Rio Grande on its northwestward course centuries ago. This abrupt change in the river's course had been known by mapmakers for hundreds of years, but it remained for Lieutenant William H. C. Whiting of the Army Topographical Engineers to bestow the graphically descriptive name Big Bend in 1849.

I finally left the park by way of Santa Elena Canyon, which has always been one of the most striking features in the Big Bend. I recalled my excitement at discovering the report of the first Spanish expedition to see the canyon and the massive Mesa de Anguila from which it is eroded. In 1747 Governor Pedro de Rábago y Terán of Coahuila led an exploring party into what the Spaniards called the *despoblado*, or uninhabited land, hoping to find a good route from San Juan Bautista, near present-day Eagle Pass, to Presidio, which would have enabled the Spaniards to better defend their settlements from the quick-hitting and mobile bands of Comanches who marauded the frontier. Rábago's expedition technically was a failure for, although he had safely reached Presidio, he had crossed such harsh terrain that it would be only with great difficulty that any expedition could retrace his steps. The Spaniards eventually withdrew from the Big Bend and formed their defensive line farther to the south. But Rábago had recorded in his journal on the morning of December 11 that he had taken a short walk out of camp and, as the fog lifted, had seen the canyon in the distance. After exploring only a few hundred feet into its mouth—until the "walls rose vertically out of the water"—he returned to camp and wrote that he had named the canyon and its fault line the "wall of San Damasio." No one really knows how the canyon got its present name, and I have often thought of the appropriateness of Rábago's term, for it is, indeed, a formidable wall with sheer cliffs that reach 1,500 feet in height.

Standing in front of Santa Elena I permitted myself a few minutes of historical mind-play. The government boundary surveyors had approached cautiously in 1852. They sent an unmanned boat through the canyon, and "no two planks came out together." There were undoubtedly hidden treacheries in this placid-looking canyon, and they decided to skip them. Captain Charles Nevill of the Texas Rangers was not so fortunate as he accompanied a surveying party through the canyon in 1882. The captain almost lost his life in one of the deceptively swift whirlpools. He did lose his favorite pipe. His boat hit one of the partially submerged boulders near the rock slide, and he was carried down the river as though he had been "shot out of a gun." "All this time I had my pipe in my mouth," he wrote. "I hated to give it up [but] I went under, and being so played I thought I would never make it out, and would have no further use for a fine pipe, I spit it out." Nevill finally struggled over to one of the narrow strips of beach, but the recollection of his close call reminded me of the warning my party had received as we prepared for a float trip down the lower canyons, several miles northeast of the park. A woman, our expedition leader had informed us, had drowned in Santa Elena the previous week. The information itself had been adequate notice. We kept our life jackets constantly strapped on.

I walked back to the car and turned up the road that runs parallel to the Rio Grande northwestward to Presidio. The extensive development around Lajitas, just outside the park on the southwestern side, had begun, and I wondered at the juxtaposition offered by modern, prefab motel units within the shadow of cliffs that have not changed since the Spaniards said masses over them and claimed them for the crown more than four centuries ago.

The nearby Lajitas general store brought to mind an incident that a bemused park official had told me about the early days of the park. Maggie Smith's general store was located on park

land, but she was a popular storekeeper, so, rather than force her to move, the park ranger suggested that she remain in business but permit the park service to pursue its educational goal by putting an interpretative exhibit in her store. Maggie agreed, and an exhibit of typical ranching habiliments was installed. When the ranger returned several weeks later to check on the exhibit, he found that she had sold everything. "They were good clothes," she explained, and she gave the ranger his money.

Just outside of Lajitas the road begins to climb, and I was soon steering my rental car around the sharp curves and down the steep grades of one of the Texas Highway Department's most beautiful roads, F.M. 170 from Lajitas through the Chinati Mountains to Presidio—the River Road. It is a modern miracle that would have dazzled the pioneers. When Lieutenant William H. Smith of the Topographical Engineers, one of the first men to think seriously about building a road through the Big Bend, saw the mountains in 1852, he predicted, "When the nature of the country is seen by those who hereafter pass over the road, it may excite surprise; but it will not be that so practical a route has been found, but rather that any was found at all."

As I left the mountains and headed onto the rolling river bottomland, I decided to visit the newly reconstructed Fort Leaton. Ben Leaton was one of the first ranchers to settle in the Big Bend. After the conclusion of the war with Mexico in 1848, Leaton and several friends came north along what became known as the Chihuahua Trail. When Leaton reached the fertile Rio Grande, he decided to stay. He became a successful rancher and established himself as a man to be feared and respected. But he is best known for an incident that probably never happened. According to tradition, Leaton, in an effort to befriend his Indian neighbors, invited them to a feast at his *rancho*. They all enjoyed themselves immensely, but the next day Leaton discovered that the red men had stolen his horses. His revenge was calculated. After several months, he invited them to another feast. Apparently believing that all was forgiven, they fell into his deadly trap. At the height of the feast, with the Indians supposedly drunk and

almost insensible, he pulled curtains aside to reveal a cannon. His men fired on the helpless victims, and Leaton had his revenge. All this raced through my mind as I entered the reconstructed adobe house. The history as told by the State Parks and Wildlife Department wisely makes no mention of this tale.

I was still ahead of schedule when I arrived in Presidio, so I looked at my Hertz map and discovered that F.M. 170 continued from Presidio, through Ruidosa and Candelaria, to Van Horn. I had never traveled that route. The longer drive would have been northeastward through the old silver mining town of Shafter to Marfa, then northwestward to Van Horn. My ultimate destination was El Paso, where I was to catch an evening flight to Albuquerque. The timing was close, but my historical sense was aroused as I recalled that old photograph of Texas National Guard troops heading pell-mell down a slope in search of Mexican bandits, and the prospect of going through Candelaria stirred my desire to walk on historic ground in the manner of historian Edward Gibbon and countless others, so I decided on what appeared to be the more direct and interesting route. I set out for Van Horn via Ruidosa and Candelaria.

F.M. 170 continues to parallel the Rio Grande for almost thirty miles before it reaches Ruidosa. I was not alarmed when it turned from asphalt to gravel, then from gravel to powdery river clay. I slowed to accommodate the frequent washouts and ditches, often rechecking the map to be sure that I had not missed a turn. A clear and reassuring black line led from Presidio through Ruidosa and Candelaria en route to Van Horn and U.S. 90. Only a few more miles, I felt, and I would be on my way, with firsthand experience of these frontier villages. As distant puffs of dust turned into pickup trucks that whooshed past me, even a less-than-normal imagination would have conjured up modern-day Pancho Villas hauling some kind of locoweed across the border. But I assured myself that if most of the bandit scares in 1915–16, the height of the border troubles, were false alarms, I was surely safe today.

Of course, not all the threats were false. Bandits had hit two

spots in southern Brewster County in 1916, Glenn Springs and Jesse Deemer's Store, and Colonel George T. Langhorne, like "Black Jack" Pershing, had taken troops into Mexico in hot pursuit of the bandits. The recent warning of a border patrolman that "unprecedented" numbers of illegal aliens were crossing the river in deserted areas popped into my mind, but the next pickup to pass me put me at ease; a huge and joyous family headed to town for their Saturday shopping spree assured me that I was actually on a well-traveled and safe road.

I was not disappointed in the villages. Ruidosa is a small collection of adobe huts seemingly untouched by the ravages of the past half-century. Only the pickup trucks parked by the few structures give away the year, but I could not stop to enjoy this time capsule, for I now realized that I had lost hours on the dirt roads. It was now well after noon, and I was still a long way from El Paso.

Another ten miles or so and I reached Candelaria. There was no time to explore, but I had to stop because, after driving into the plazalike area, in reality a plot of dirt surrounded by several buildings including a small general store, I could not tell which way the road went. I parked my car, thinking only fleetingly of the chance that it would not start when I returned, and walked into the general store to ask for directions.

Two well-scrubbed and immaculately dressed ladies turned to wait on me. Perhaps they were prepared to tell another weekend adventurer that the well-known Capote Falls were nearby but on private land that could be visited only with an invitation from the rancher who has protected them over the years. My plaintive request for directions to Van Horn seemed to surprise them—or was it my naiveté? At any rate, one of them explained that if I was not prepared to ford the Rio Grande—the bridge had washed out years ago—and continue on the Mexican side, I would have to return to Presidio and proceed through Marfa. There was a shortcut from Ruidosa to Marfa if I did not mind more dirt roads. There was no sign to mark the turn, she explained, but I should watch for a road leading out of town to the left.

The Big Bend had finally worked its magic on me. I had tried to rush through it as if it were a newsreel with its highlights flashing before my eyes, but the moment I got off of the beaten trails I had to slow down to match its pace. Now I was virtually certain to miss my flight, but I could afford to be more deliberate in my sight-seeing. No doubt this timeless and ageless quality is one of the characteristics that has attracted so many artists over the years.

It was not so easy for the first artists to reach this isolated and unmapped country. As members of the 1852 boundary survey, both Mexican and American, they had been trained in topographical drawing. Arthur C. V. Schott documented the rock slide in Santa Elena and the remains of the old Spanish presidio at San Vicente, and an unknown Mexican artist recorded the first image of the Chisos Mountains, with Emory Peak, named for William H. Emory, the chief surveyor of the American team, reaching some 7,835 feet into the sky. But theirs was a difficult task. The American team's boats were wrecked in Mariscal Canyon, and they lost all of their supplies. They came out of the canyon in "destitute condition" and unable to continue the survey. "The sharp rocks of the mountains had cut the shoes from their feet," said one, "and blood, in many instances, marked their progress through the day's work."

The region took another step closer to civilization when the soldiers arrived at Fort Davis in 1854. Built on the San Antonio–El Paso road to protect travelers, the fort soon drew settlers around it, and ranching became one of the region's major occupations. An excellent visual record of the early fort survives because Captain Arthur T. Lee, a talented watercolorist, was among the first officers assigned to it.

As the Southern Pacific completed its "Sunshine Route" from San Antonio to the Pacific in 1882, so little was known about the Big Bend that an El Paso newspaper editor offered a reward for anyone who would lead an expedition into the unknowns of the "Great Bend." The man who accepted the challenge in 1899 was Dr. Robert T. Hill, a geologist working for the U.S. Geological Survey in an effort to complete a map of the state. Hill approached the

float trip from Presidio down the Rio Grande to Langtry with scientific skill, but with a healthy respect for the myths and legends of the Big Bend. He probably was disappointed when no bandits threatened the survival of his armed and alert group, particularly when he later concluded that he had peacefully encountered the most notorious of all the border desperados. Hill's resulting study of Texas, as well as a popular article on the region in *Century*, earned him the title of "father of Texas geology."

Perhaps the most widely publicized assault on the obscurity of the Big Bend, however, came at the hands of Dr. Walter Prescott Webb, the talented and well-known historian at the University of Texas at Austin. The Park Service had employed the author of *The Texas Rangers* and *The Great Plains* to write a history of this soon-to-be-developed park, and Webb decided in 1937 that he needed to make a trip through Santa Elena Canyon, both for his research and to gain publicity for the new park. Declaring that the canyon had rarely been traversed, Webb laid elaborate plans for his effort. He employed the most experienced guides. Recalling that the boundary survey's craft had been smashed to bits in 1852, he ordered special flat-bottom boats made of steel. Finally, he arranged for a Coast Guard plane to fly over daily to be sure that all was well with the expedition. He would communicate with the pilot by semaphore. The pilot would then flash the news to Webb's wife and to the wire services. With planning for his expedition complete, Webb systematically contacted all the major newspapers in the state, trying to sell the story of his adventure in advance.

Imagine Webb's chagrin when his research turned up the fact that in 1930 two servicemen and a border patrolman from Fort D. A. Russell, near Marfa, curious about the river canyons, had swum and waded through Santa Elena after abandoning their raft at the rock slide. Webb preserved this bit of information among his papers, but never mentioned it in any of the subsequent stories he wrote about his successful completion of this dangerous trip.

By the time Webb began his study, artists had discovered the astonishing calmness of the Trans-Pecos for themselves. Terrain that had reminded the ancient Indians of a pile of leftovers that an indifferent Creator had hurled into an out-of-the-way place, and that later qualified as a testing ground for the astronauts simulating the moonscape, also appealed to them. The extremes of nature are juxtaposed: desert lowlands and alpine heights, intense sun and shade. Then there is the unpredictable weather: when it rains, vast, dark sheets move across the landscape like a rolling wave, quickly changing the dusty arroyos into rampaging rivers. The resulting abstractions of nature draw artists back year after year. While Grant Wood and John Stewart Curry searched the Midwest for America's essential character, Jerry Bywaters, Otis Dozier, and Everett Spruce discovered the Big Bend. Just as the wilderness had asserted its influence on nineteenth-century painters, so did the Big Bend intrigue the generation of the Great Depression.

The early-day ranchers learned to accept the changeable weather, but cursed it nonetheless. Will Tom Carpenter experienced a typical storm during a cattle drive in 1892 or 1893. The ranch owner had asked him to move a herd of almost 2,000 cattle from a range near Alpine to some property he owned east of the Pecos. Carpenter and a crew of seven or eight cowboys started out Christmas week in a fog so thick that they lost the herd three nights in a row before they got underway. As soon as they got the cattle walking, it began to snow. Two and a half inches accumulated before they crossed the Southern Pacific Railroad east of Alpine. By the time they reached Fort Stockton, a steady rain had begun, which soon turned to snow. As the temperature plunged, the snow turned to ice, and several cattle froze to death during the night.

But Carpenter did not turn back. As they approached the Pecos, the cattle hurried toward it to drink. He thought the hard part was over and picked out a spot with sloping banks so the cattle could get over easily. The riders urged them into the river, but they would not go. These Big Bend–raised cattle were unaccustomed to so much water and were afraid. The second night they bedded them down close to the river so they would get accus-

tomed to the noise, and they had no trouble walking them across the next morning.

The sudden appearance of Ruidosa and the road leading to Marfa jarred me back to the reality of my situation—I was still miles from my destination and, for all practical purposes, lost, my sketchy map being of no use at all for this leg of the journey. I turned toward the northwest, hardly anticipating the spectacular mountains of this vast ranchland—mountains that forced me to slow down out of awe as well as danger. As I wound up and down the mountains and through the sandy valleys, I drove over cliff roads that could not have accommodated two vehicles had I encountered anyone. Chinati Peak to the south of the road dominated the view, and as I climbed down from the mountains I was forced several times to pause and take in the beauty of this virgin country.

Finally, as I roared over a small hill, with dust plume in tow, I hit the promised pavement and blew past a waving border patrolman, no doubt lying in wait for the smugglers I had wondered about. Realizing that I, in my rented car with out-of-state license plates, probably looked more like a smuggler than anyone he had arrested this year, I pulled to the side of the road as he approached. I described my day's activities in enough detail that he motioned me on, and I was not too distressed to notice that he took down my license number.

Once again on the road, I tried to calculate the time now required for the drive to El Paso. I had given up hope, because I was still miles from Marfa. Only then could I accurately judge the time it would take for the rest of the trip.

But, wait! As I topped the next hill, there was Marfa, laid out in the valley before me just as clearly as it was in the many nineteenth-century glass-plate photographic negatives that I had seen of the city, which was founded as a way-station on the Southern Pacific in 1882. The jagged peaks of the Davis Mountains and Mount Livermore, more than 8,000 feet high, were clearly visible as a backdrop to the city. I could not be more than five minutes away. I might make it yet.

As I whisked confidently along, dialing the radio in hopes of picking up the local radio station, I passed a road sign indicating that Marfa was more than thirty miles away. I had been badly fooled for the second time. I later learned that the Davis Mountains were another twenty miles beyond the city. On this clear day I had a stunning vision of at least fifty and perhaps one hundred miles of the Big Bend country, laid out before me in convincing detail. No wonder the McDonald Observatory is nestled into those mountains—to take advantage of some of the clearest skies in the country.

Needless to say, I missed my flight—not by minutes, but by hours. I found myself turning north toward Albuquerque, my final destination, at midnight.

This experience with distance and clarity of vision in the Big Bend made a profound impression on me. I recalled the diaries and journals of the early-day travelers who lamented the distances and the unhindered and withering sun. I thought of the army officers who first rode the Arabian camels into the Trans-Pecos, hoping to prove that they would be an acceptable means of transportation until the transcontinental railroad could be completed. The mountains receded before them, they said, and they were never as near to them as they thought—and hence to the streams and water holes trapped in their crevices.

I also remembered that artists treasured a pellucid atmosphere. Frederic Remington had frequently spoken of the Southwestern light as a shaping element in his palette, and the first trained landscape painters to reach the Great Plains marveled at the vast, horizontal vistas and clear sky. Similarly, the Trans-Pecos sun seems virtually unfiltered by the earth's atmosphere and bleaches color from its subjects while, at the same time, creating dark and dramatic shadows. It is no accident that clear, bright light is a dominant theme for the truthful artist working in the Big Bend.

In the Albuquerque airport the next day, I walked over earth-colored tiles and waited in lounges decorated in what can be described only as Southwestern desert modern. In a few moments

I was airborne, retracing my route of the previous day but at an altitude of 28,000 feet, which intensified my understanding of the loneliness and remoteness of the Big Bend Country—and the necessity that it stay that way.

RON TYLER
February, 1983

Pecos to Rio Grande: *Interpretations of Far West Texas by Eighteen Artists*

Soaring to Great Heights

As you travel west between cactus and wild flowers heading for
Santa Elena Canyon, look left. Jutting from the flat desert floor
are mammoth rocks—the mountains of Big Bend. Now let your
eyes pass through the V-shaped window and across the cool basin
to majestic Casa Grande. And on the hot-air currents rising above
you'll be fascinated to see the graceful free spirits "Soaring to
Great Heights."

FINIS F. COLLINS

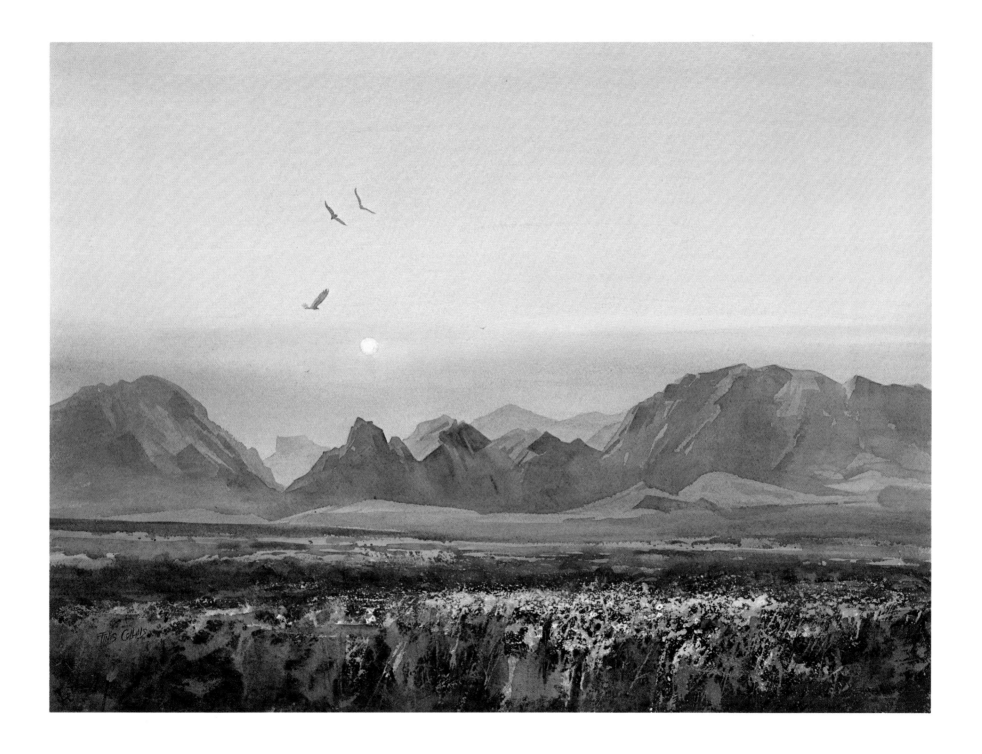

Santa Elena Canyon

Chisos Mountains means "enchanted." This is the section of the Santa Elena Canyon where, because of an optical illusion caused by the huge canyon wall, the Rio Grande appears to run uphill.

MARBURY HILL BROWN

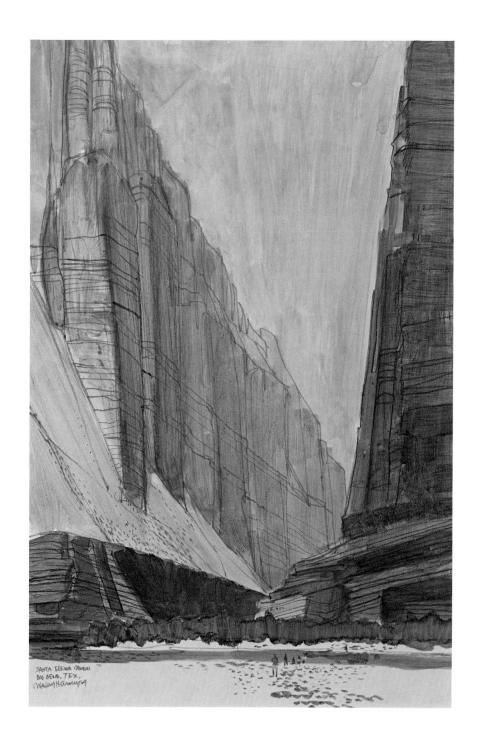

SANTA ELENA CANYON
BIG BEND, TEX.
Wally Harrington

Bunkhouses

These bunkhouses, painted in 1938, were two of several scattered around a big ranch headquarters south of Alpine. Each little house had different character and details, and each was properly attended by a windmill with its own individuality.

JERRY BYWATERS

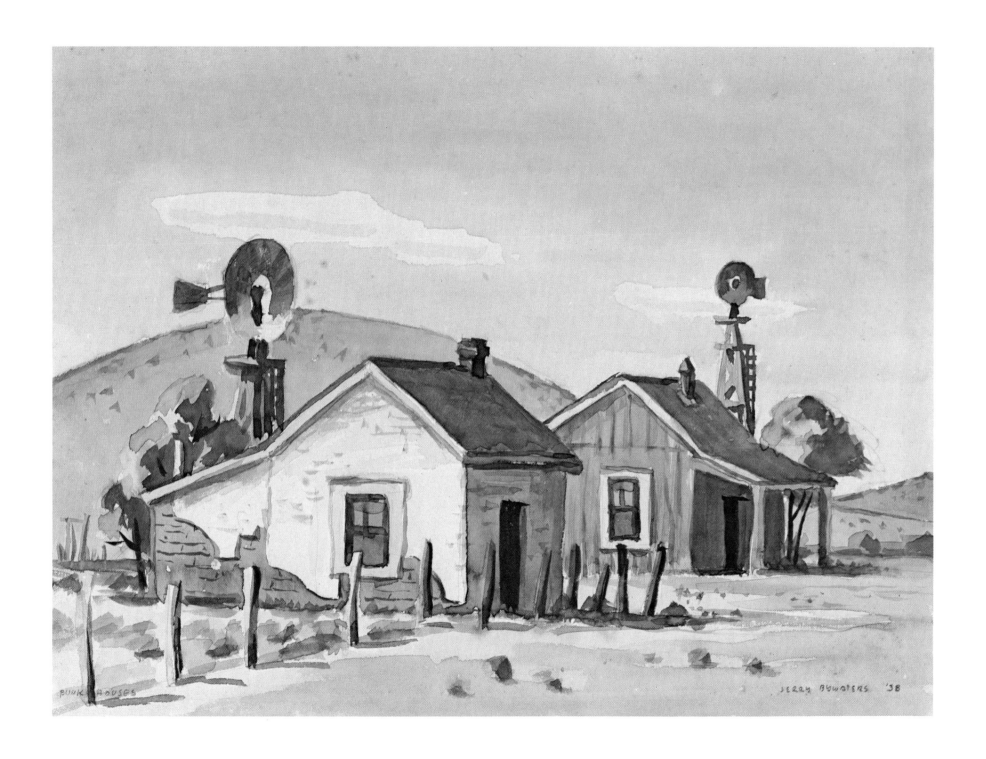

BUNK HOUSES

JERRY BYWATERS '38

Old Terlingua

Terlingua calls back many memories. I was there when the mine was active. It was a painter's delight—small houses of adobe and rock with little gardens fenced by ocotillo (in bloom when I first saw it). In the evening people began to come out to visit and talk to neighbors and to amble toward a long building—the company store. This sketch was made after the mines closed.

OTIS DOZIER

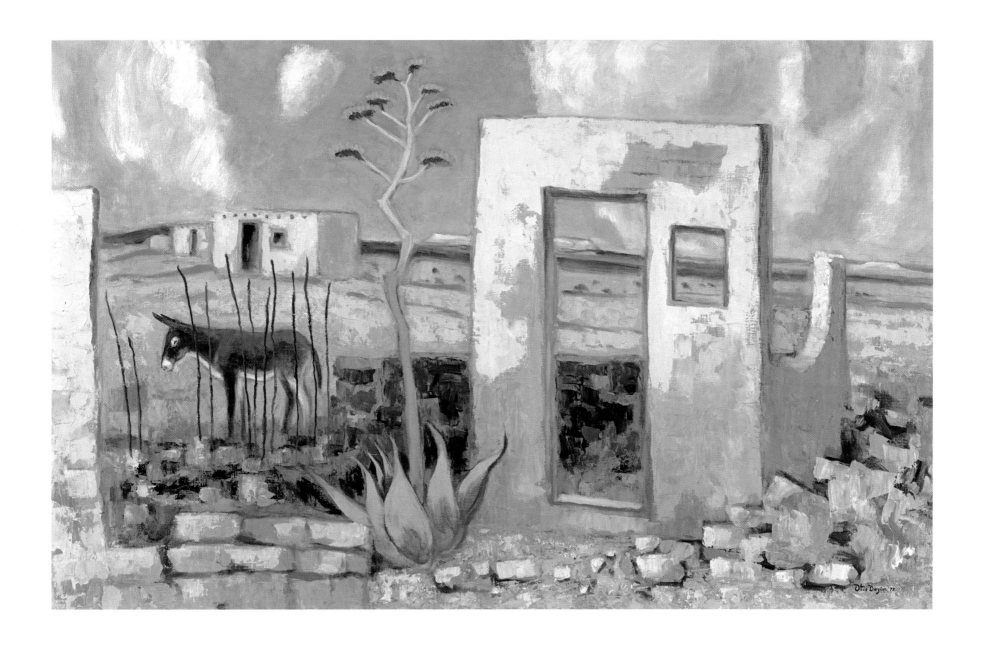

Farmlands Below the Chisos

I was driving west from Terlingua toward Lajitas. The silhouette of the Chisos Mountains loomed above the contrasting flat farmlands situated at their feet. The color effect of the cool volume of the mountains as opposed to the warmth of the cultivated fields interested me. This painting is not a particular location but the result of many glances at this kind of topography translated through the artist's eye.

AL BROUILLETTE

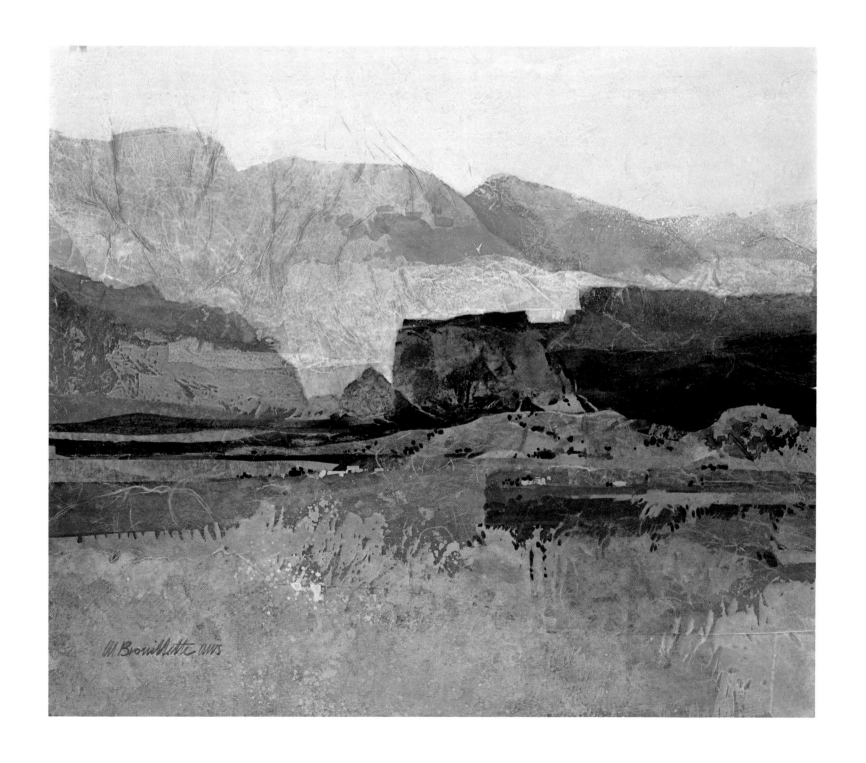

Sunset of an Era— Mineowner's Mansion, Terlingua

Though I have visited and painted the old mansion many times through the years, I think this late evening view was the most inspiring of all, and I wondered at the time how many fantastic sunsets the old mineowner had enjoyed before abandoning the grand old home.

IVAN McDOUGAL

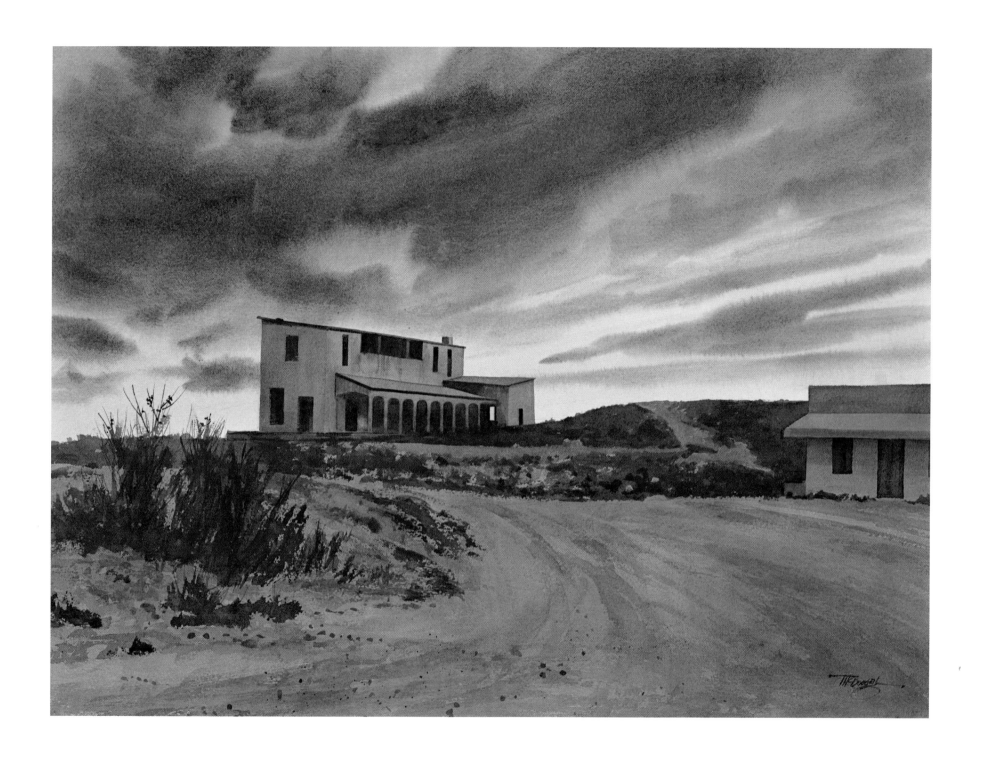

In the Davis Mountains

I was very much impressed by the architectural aspect of this particular place on the west side of the Davis range. It was late afternoon, and white clouds were moving swiftly over the landscape.

EVERETT SPRUCE

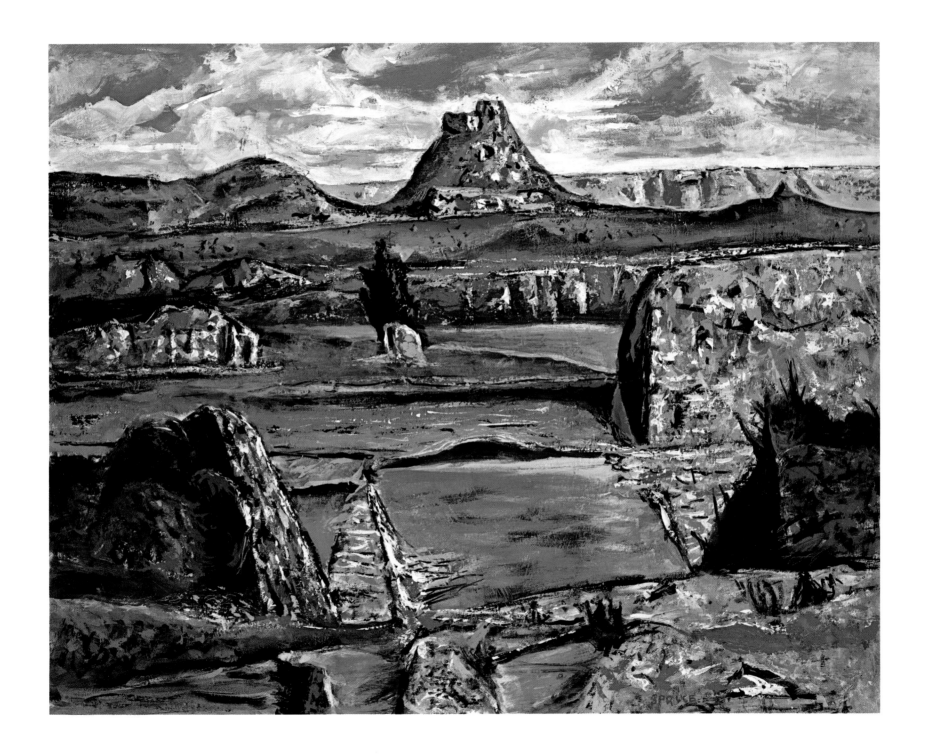

Chisos Mountains

Approaching Big Bend National Park from the west, one follows the meandering course of the Rio Grande until, at last, the rugged silhouette of the Chisos Mountains rises from the desert floor. And, again, one's memory is stirred, remembering the fragrance of pine and a morning's ride on horseback to the South Rim.

JOHN GUERIN

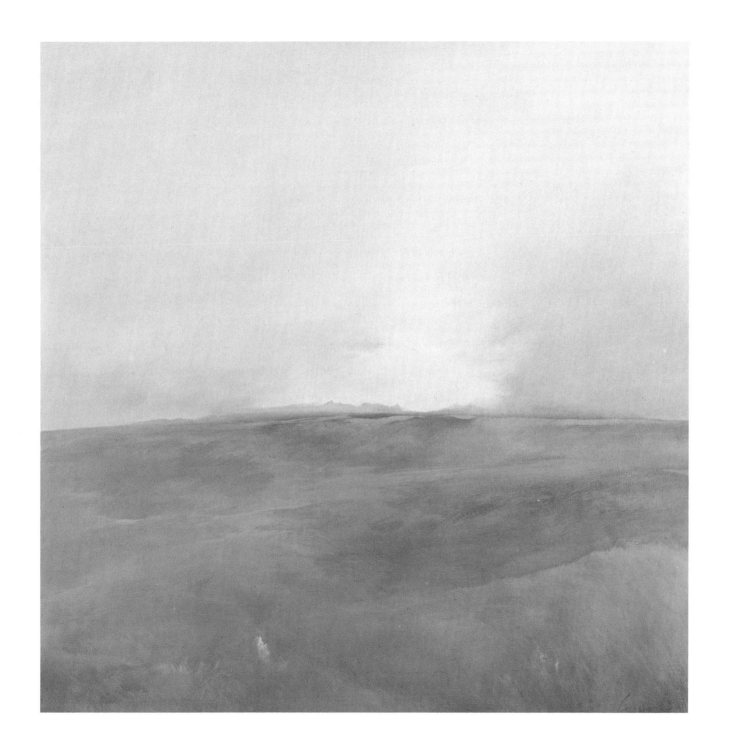

39

Alpine Hills

I came across this scene not too far south of the railroad tracks. I wanted to show the hills that surround Alpine.

<div align="right">Frank Gervasi</div>

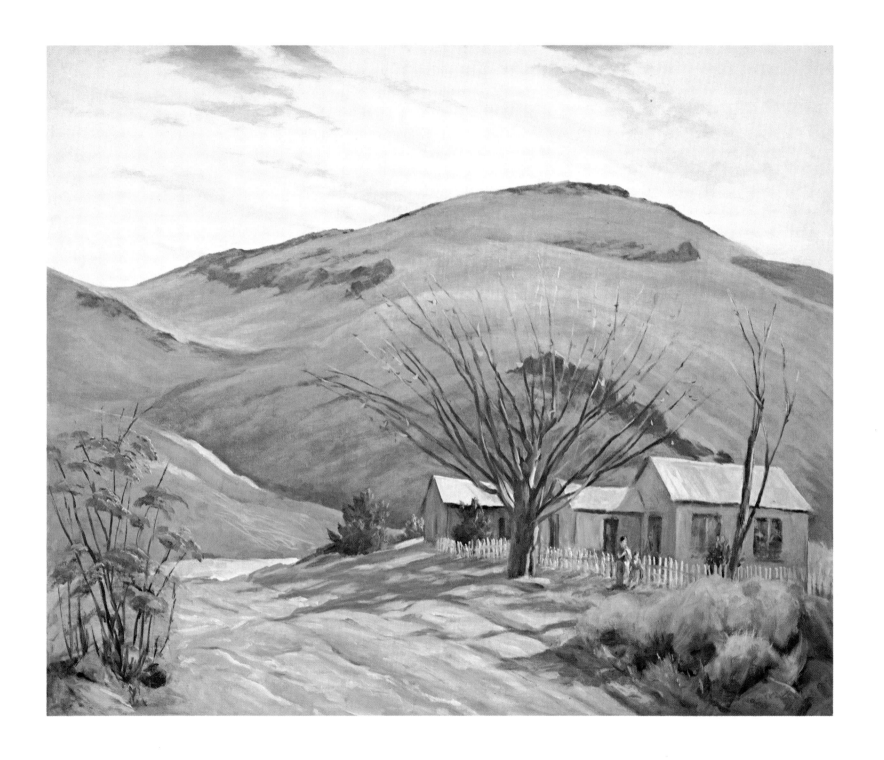

Landscape—Big Bend

My primary interest in this desert painting of the area near
Shafter was that of color—warm and cool—as of the light hitting
upon the area in the middle distance, causing an ever-changing
pattern of color.

DeForrest Judd

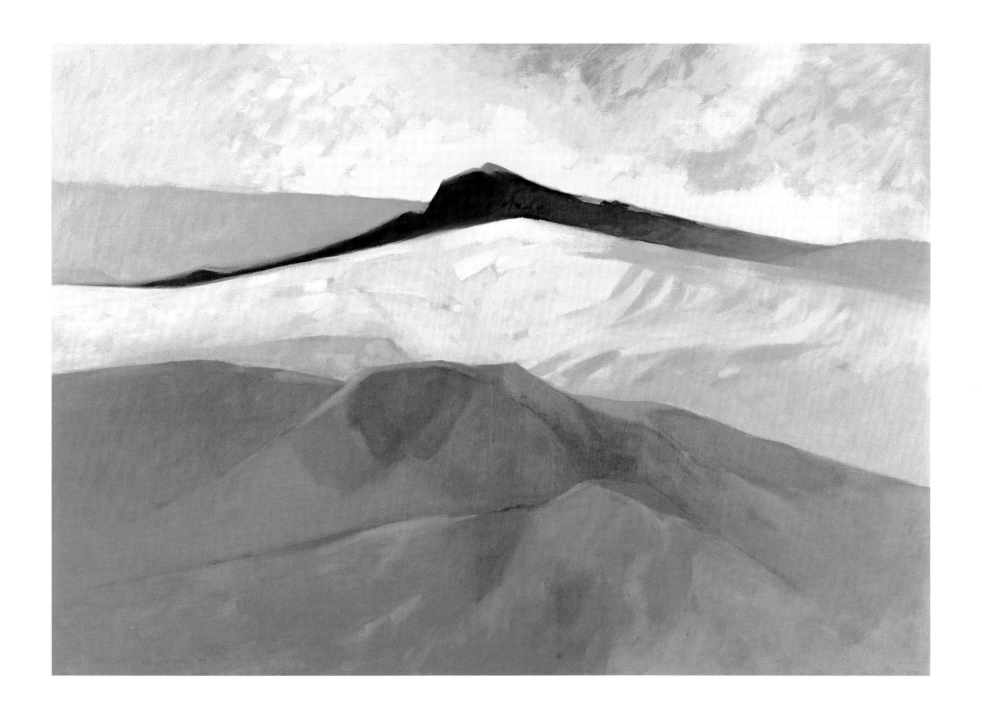

Three Peaks

This painting is based on the most arid section of the Big Bend country, that between Terlingua and Presidio. It is one of my favorite sections to visit if the time is November or December. I know of no other place in Texas where solitude and quiet are so magnificent.

WILLIAM LESTER

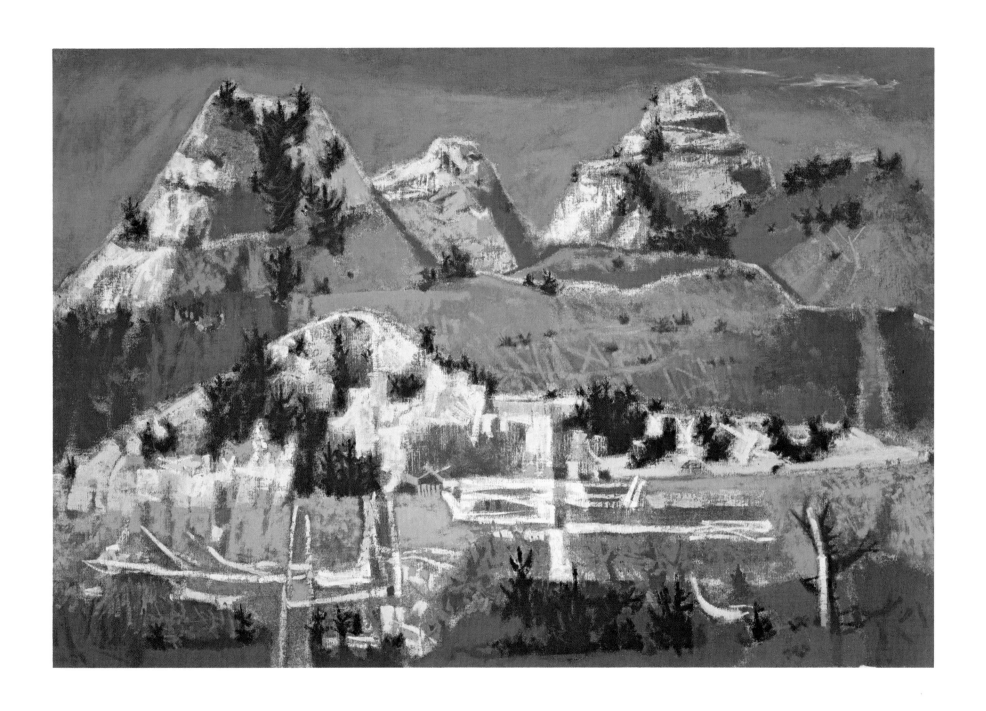

Colored Hills

No scene ever looks quite the same twice. The changing weather and changing seasons make a time and place unique—it will never recur. The artist keeps an eye out for the special once. This day the sun and shadows were playing a dreamlike, slow-motion kaleidoscope with the multicolored hills. Each seemed to be taking its turn in the spotlight, and the antelope became just "bit" players in the performance.

CLAY MCGAUGHY

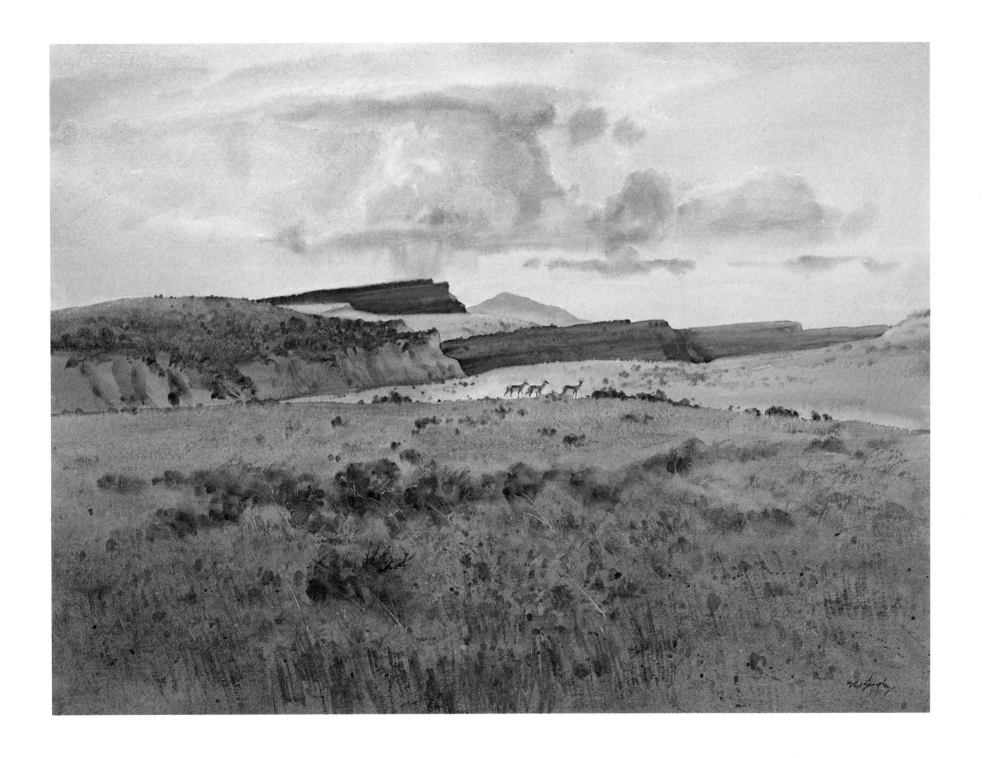

47

Goodbye

My feelings for this painting grew out of the contrasts I saw—the stormy, threatening, but beautiful sky and clouds, the solitary, lonely house against a hopeful panorama of light over the horizon—and my curiosity about who had lived there and what their lives had been.

HEATHER EDWARDS

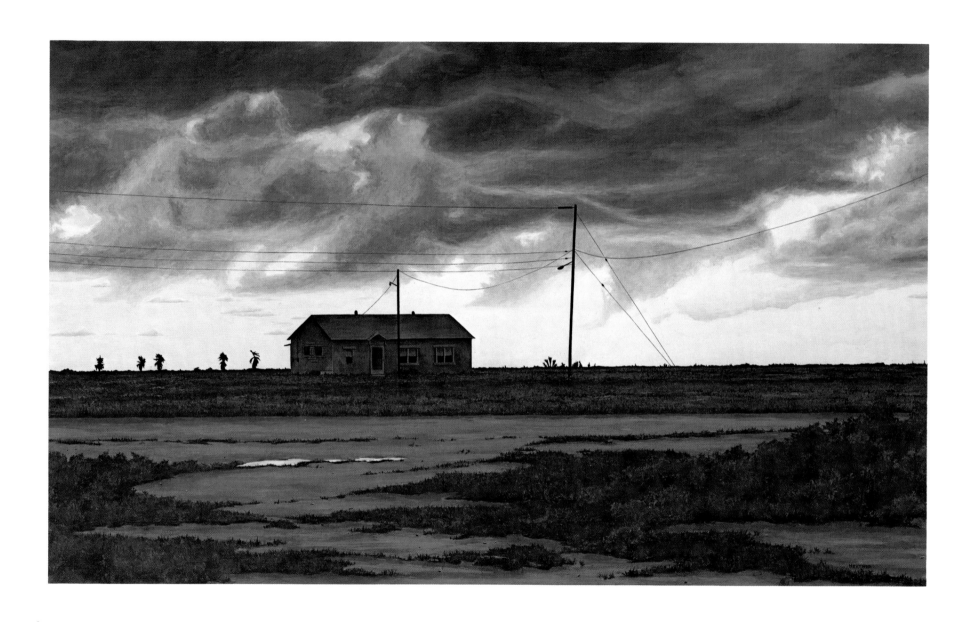

Reign

Man believes that he owns the Earth, but he is wrong. Up here in the Davis Mountains it is obvious that the land is ruled as much by the birds as by monarchs or politicians.

ANCEL E. NUNN

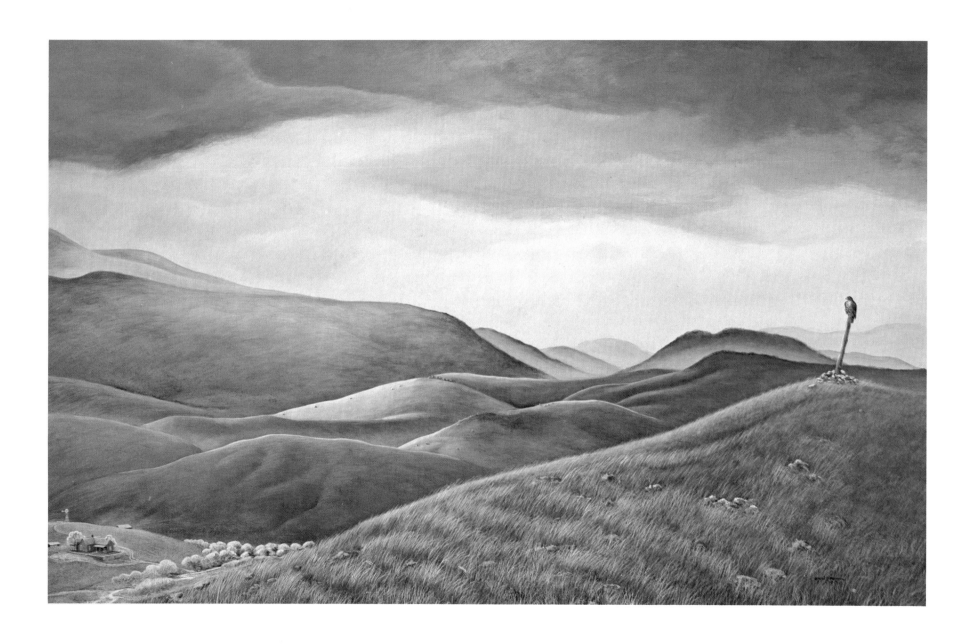

Low Water, Big Bend

On the canyon floor, one is surrounded by the walls. A place of intense *sol y sombra*, the sun lighting one wall and the opposite wall being cooled by dark shadow. Often, the shallow water ripples over fallen rocks as it moves along, quietly, downstream.

WILLIAM HOEY

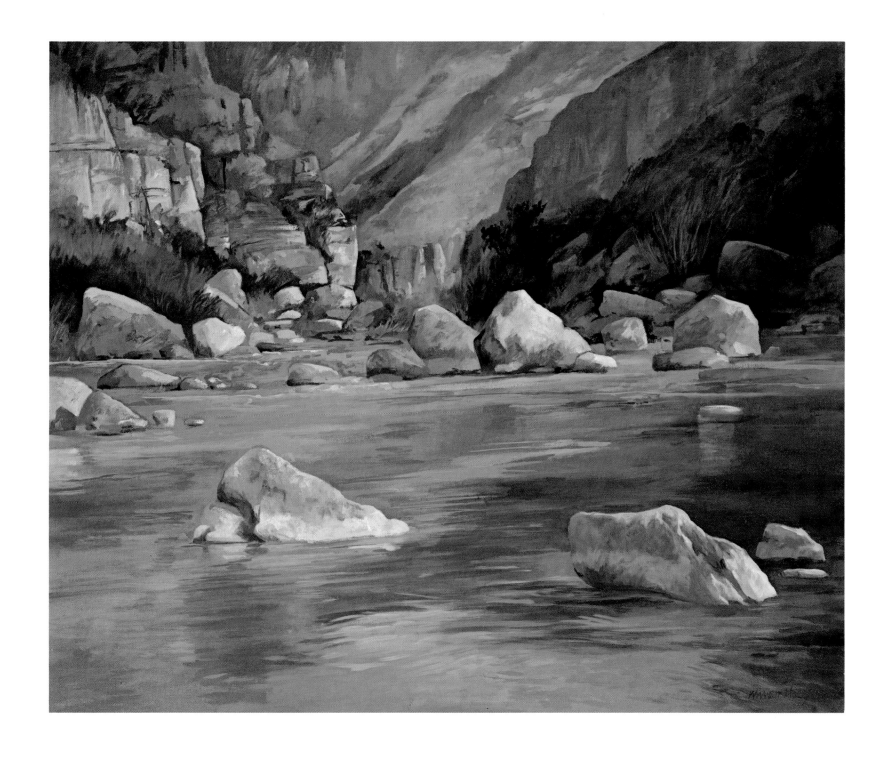

53

Aerial View of Canyon Country
with Clouds

I have flown over most of the canyons of the Southwest. This is a composite, perhaps closest to Palo Duro. The aerial view of a canyon often gives an intense impression of its tremendous size and its dramatic color.

<div align="right">STEPHEN RASCOE</div>

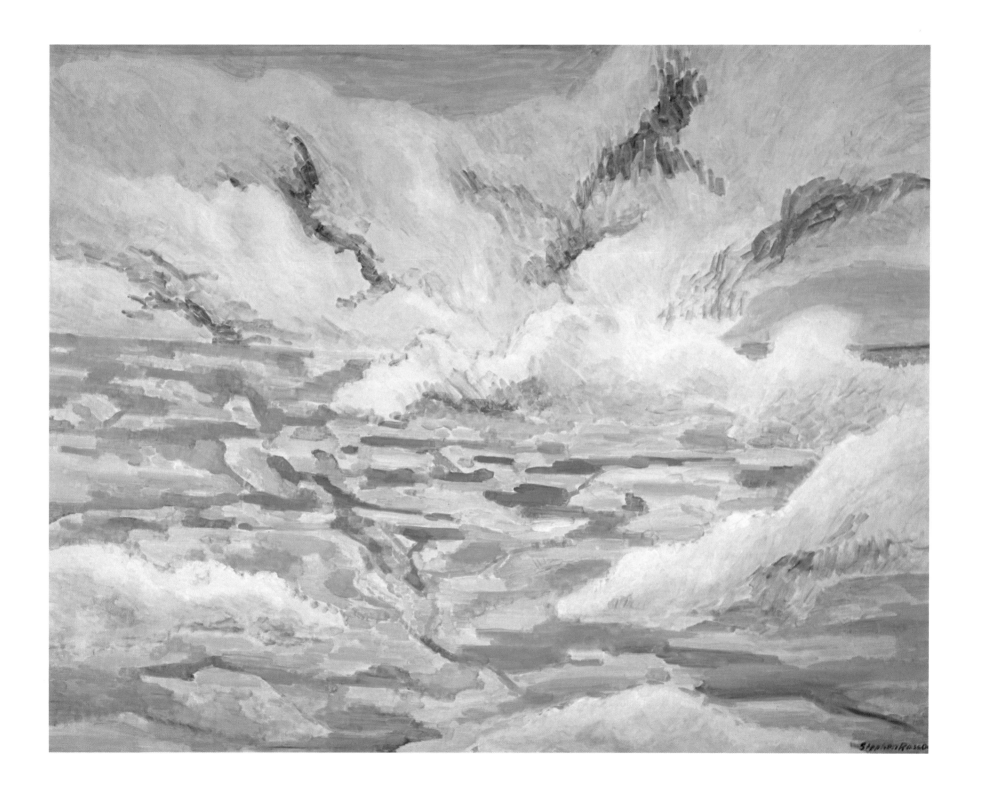

Cathedral Mountain

Some time ago my family and I were guests at the Bowmans' 101 Ranch between Alpine and Marfa. The foreman took me for painting trips many times into what he called the "*crystalles* country." Fascinating geodes, agate, petrified wood, and other geological treasures abound. On one trip I climbed Cathedral Mountain (el. 6,860), and when I came down a storm had developed in the northeast. All this Big Bend region has a sense of mystery. There are countless legends and tales of enchantment. One of the most unusual enigmas in the country, the "Marfa Lights," may be seen almost every night a few miles to the west of here.

MICHAEL FRARY

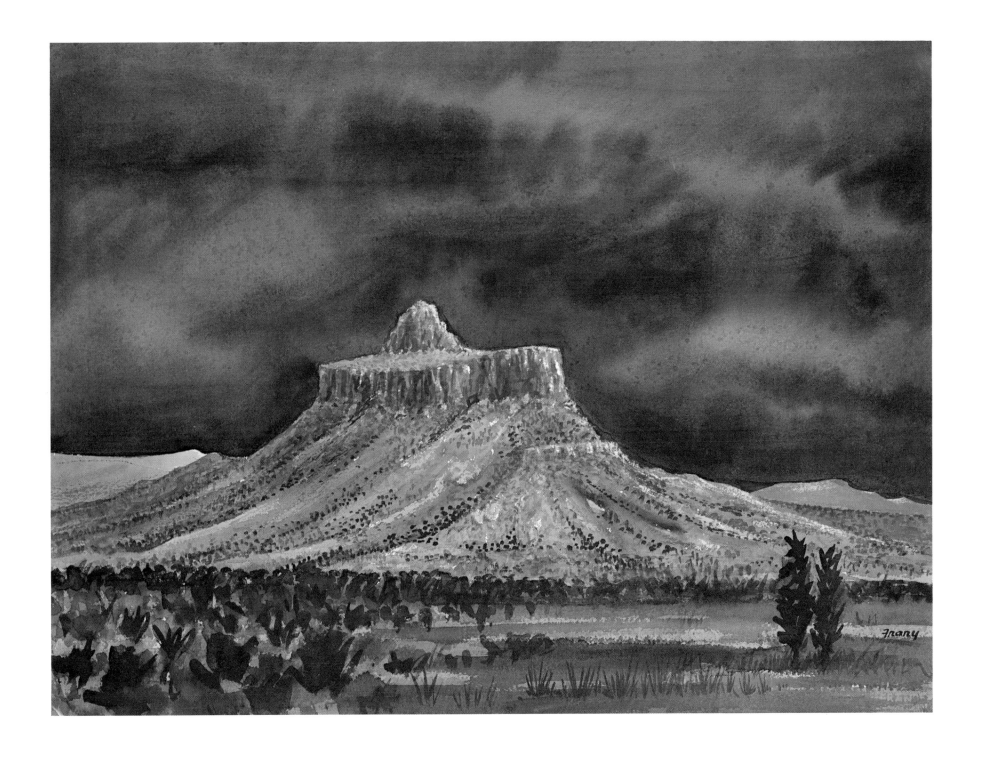

Cliffs by Presidio

As an artist, I bow to the beauty of nature's abstractions. This one is millions of years old and is located in Mexico about ten miles east of Presidio. It is seen here from across the Rio Grande. I hope my interpretation shows due appreciation of the natural designs, textures, patterns, and innate beauty.

E. Gordon West

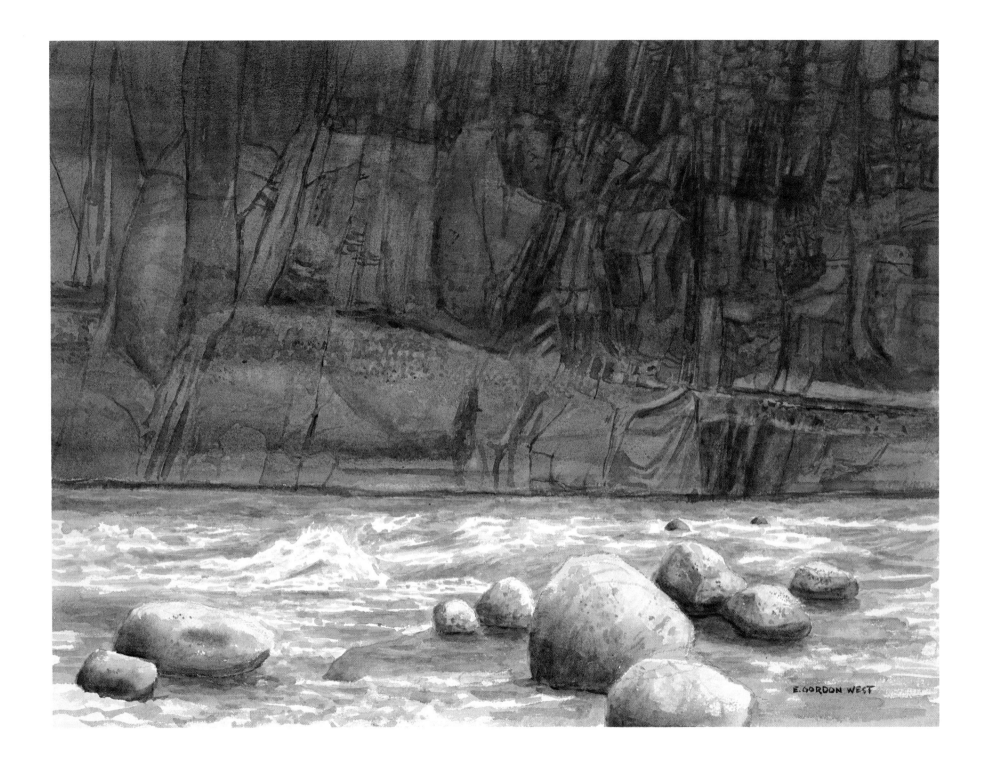

Oasis Found

Between the Pecos and the Rio Grande the burning summers turn sap greens into beautiful golden browns. The scorching sun strikes with force—the earth reflects a brilliance of hot white, while shadows become dark and dense. Your nose turns chrome red. Your gray matter bakes under your yellow straw hat, and visions of crystal clear water run cool across your imagination. This painting is a mirage composed in the fantasy of the mind's eye—I named it "Oasis Found."

FINIS F. COLLINS

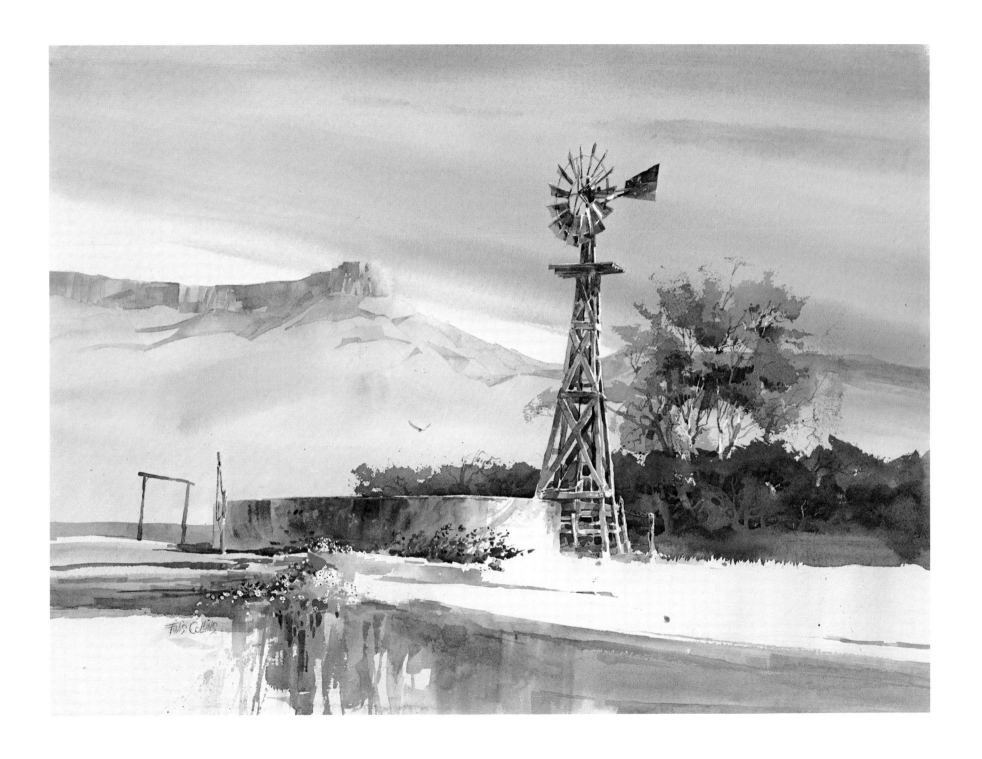

Blue Mesa—Big Bend

I think the Big Bend can best be expressed as a land of arid desert and distant mesas and a great deal of space. My aim in this view from the lowland arroyo areas east of Terlingua was to express these elements through the use of color.

DeForrest Judd

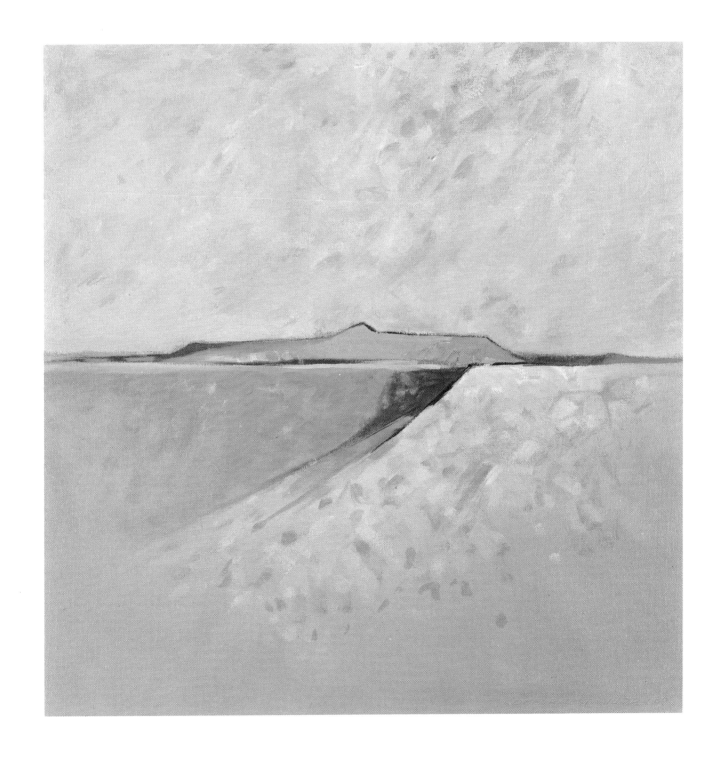

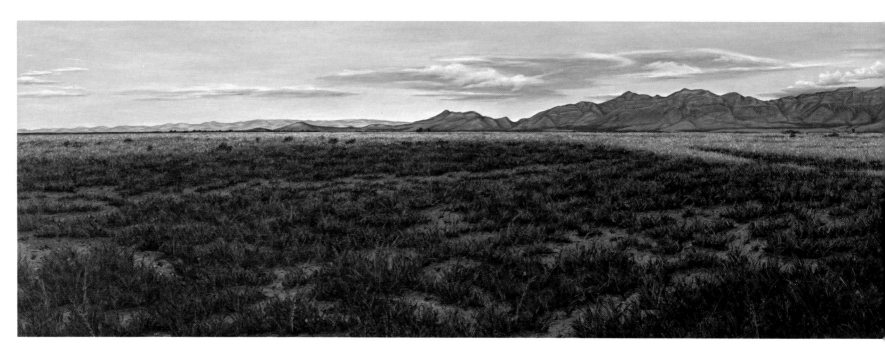

Van Horn Ranch

Sometimes, truth *is* stranger than fiction. Combine a plane trip and the culture shock of leaving the "Big City" with a long drive in a pickup across the barren wastes of West Texas, and then add to that the Sons of the Pioneers singing "Drifting Along with the Tumbling Tumbleweeds" while you are looking at the scene in this painting, and the Old West lives again.

HEATHER EDWARDS

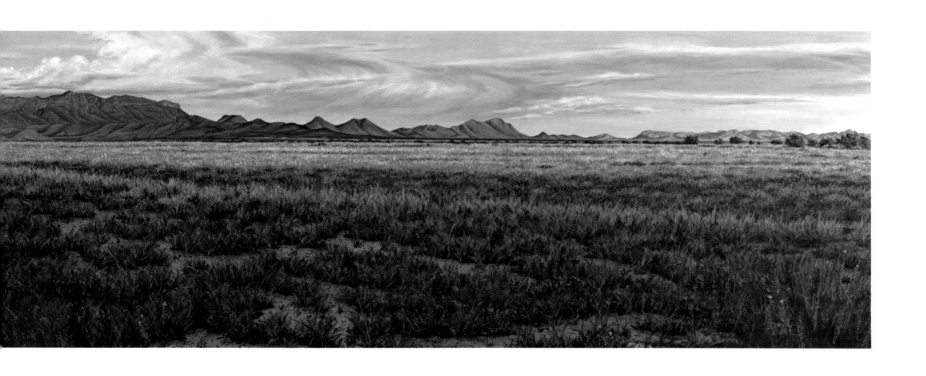

Boquillas Canyon—Big Bend

Boquillas Canyon was the most beautiful area of the Big Bend National Park and the greatest challenge to the artist.

MARBURY HILL BROWN

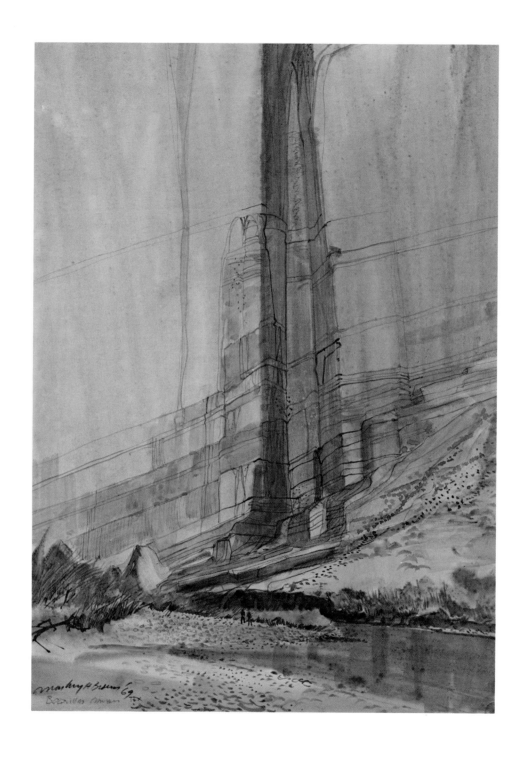

Century Plant—Big Bend

On a first trip to the Chisos Basin of the Big Bend National Park in 1937, my artist friend Otis Dozier and I camped out in an area dotted with century plants. One large plant with broken stalk intrigued me with its active forms. I made a sketch at that time, which resulted in this painting done some time later.

JERRY BYWATERS

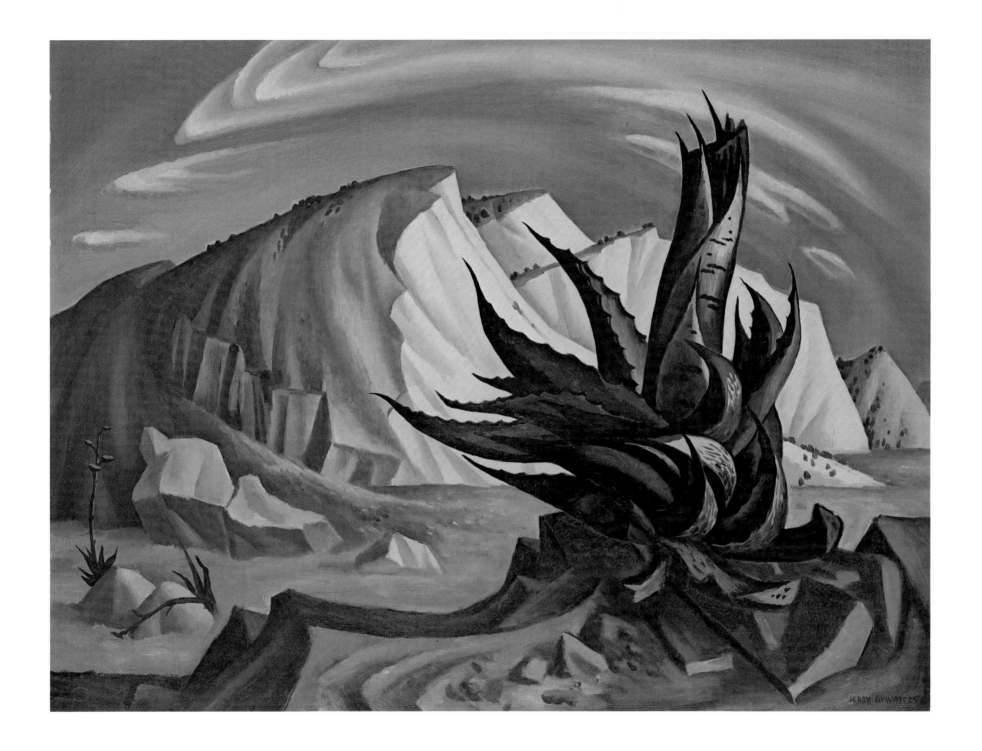

Sierra Diablo Peak

This scene lies about twenty miles north of Van Horn in the Sierra
Diablo. I explored this mountain and climbed to the top, where
the wind was unbelievably fierce. The harmony of land and sky
was impressive on that day.

EVERETT SPRUCE

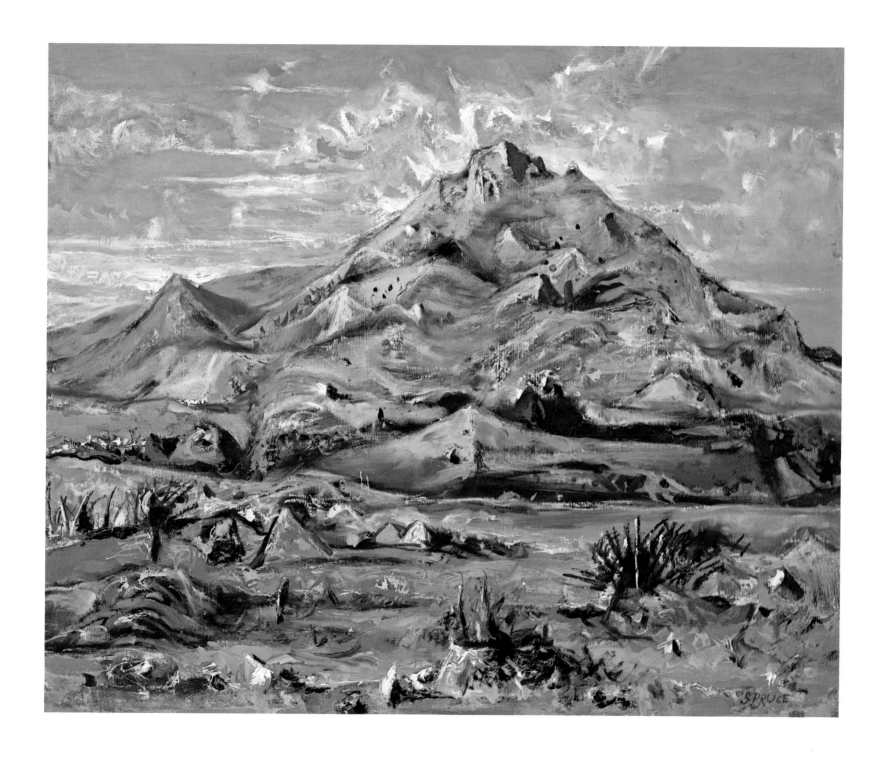

Near Fort Stockton

Fort Stockton is on the route between San Antonio and El Paso. It is north of the Big Bend and south of Midland and Odessa. It is desert country—lots of sky and oil wells.

Michael Frary

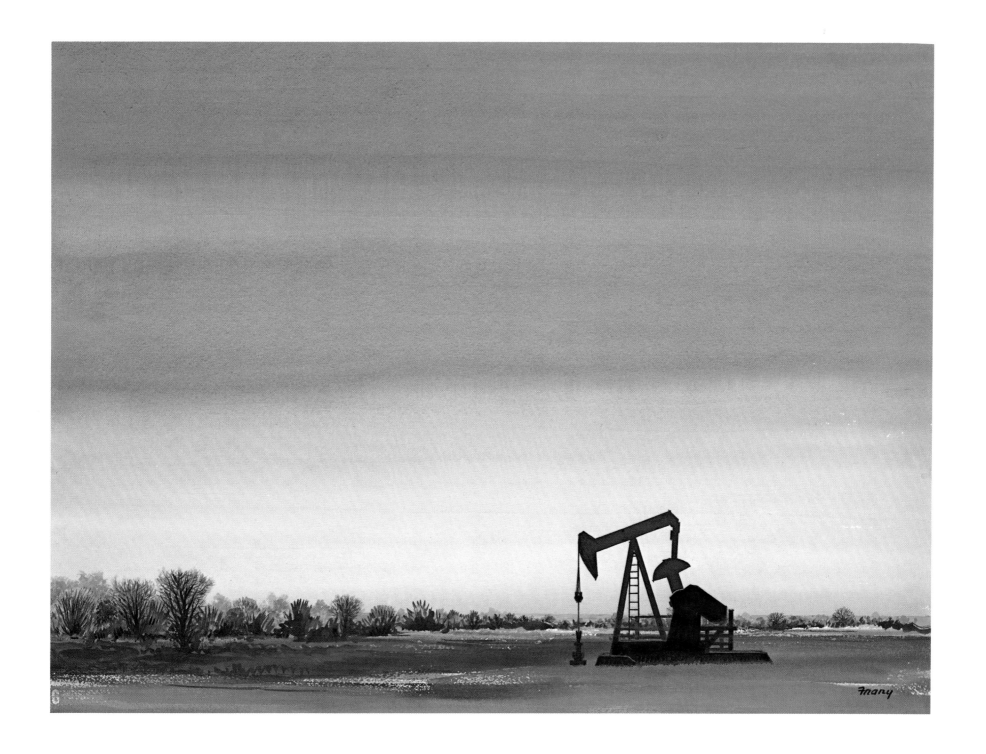

The Big Cathedral

A bit south of Alpine is Cathedral Mountain. Though I agree that it resembles a cathedral, it looks to me as much like a resting lion. It's a tough land. Maybe the pioneers took a vote and decided they needed their big cathedral; perhaps they were the lions. Either way it certainly dominates the land.

CLAY McGAUGHY

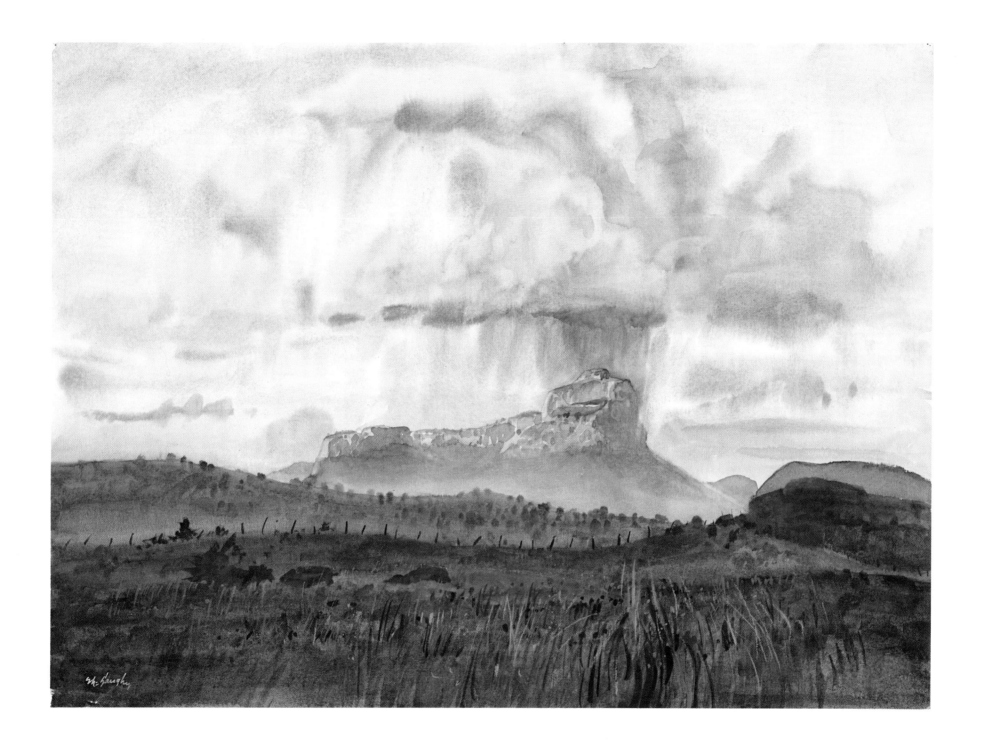

Rainstorm, Rio Grande Basin

A rainstorm in the mountains near Lajitas was as unexpected as it was unforgettable. Sudden, violent, and awe-inspiring, it cascaded down those dry, austere slopes with a force that seemed irresistible, and yet in a few short hours nothing remained to indicate its passing.

JOHN GUERIN

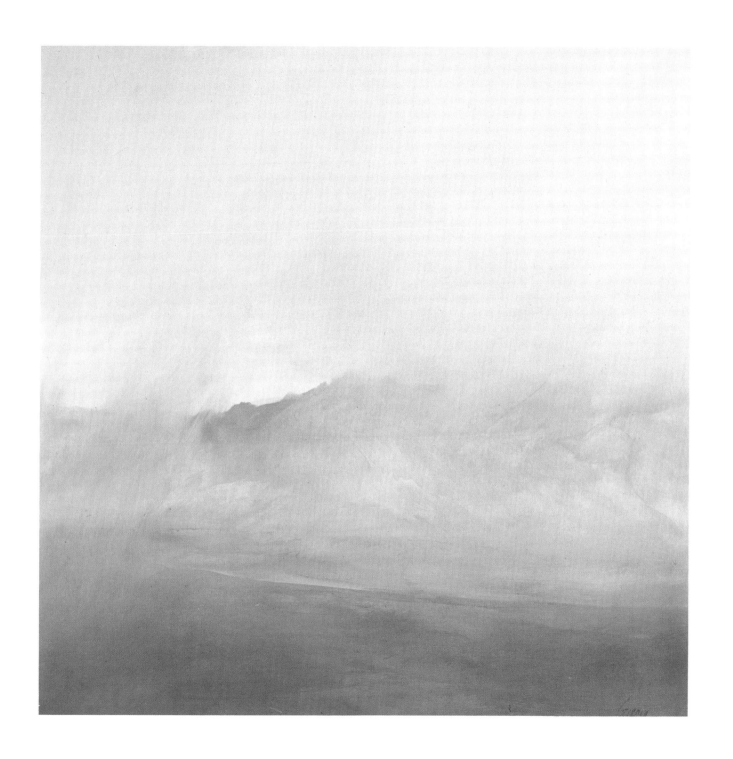

Old Fort Davis

Fort Davis was one of the several cavalry posts established in the middle and later part of the nineteenth century to protect and aid the North American settlers moving into West Texas. In 1949 and 1950 the buildings lay in neglect and decay. My painting class from Sul Ross College and I spent many hours drawing and painting the colorful skeletons of the old fort.

WILLIAM LESTER

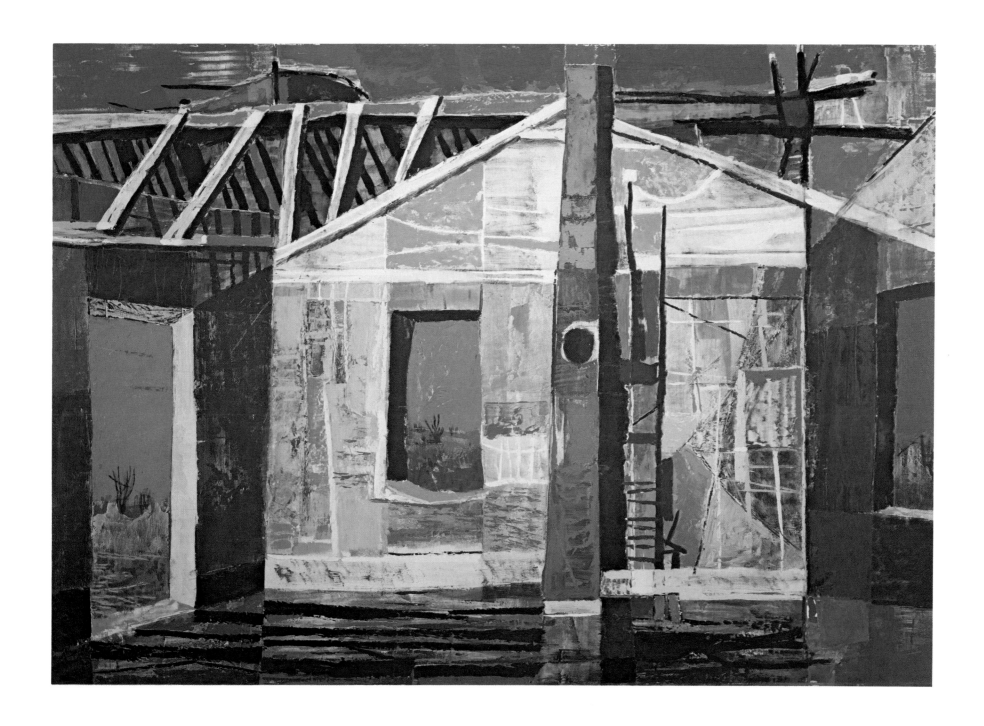

Dead End Canyon

Human presence within the confines of monumental nature can be quite intimidating—a world that diminishes one's perception of self. The feeling of soaring volume and weight is what I was trying to express. I was pleased with the painting even though I knew that again, as always, my impression was only a pale reminder of what I had seen and felt.

AL BROUILLETTE

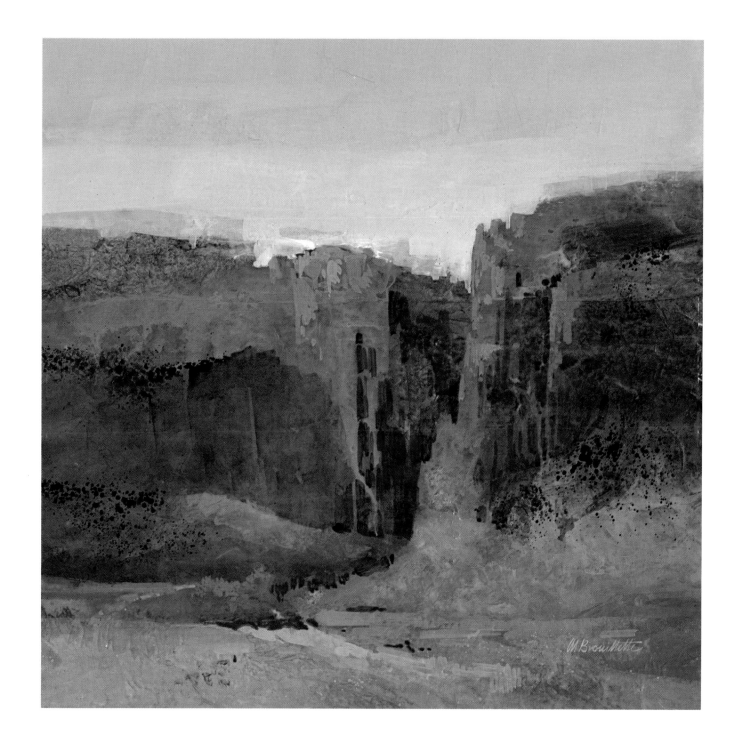

Catto Ranch near Marathon

This was the view from the bed of a bouncing pickup as our group was returning from a morning painting expedition. I was impressed by the immense distances one could see and surprised by the intense green foliage, which was due to the heavier than usual rains that spring.

IVAN McDOUGAL

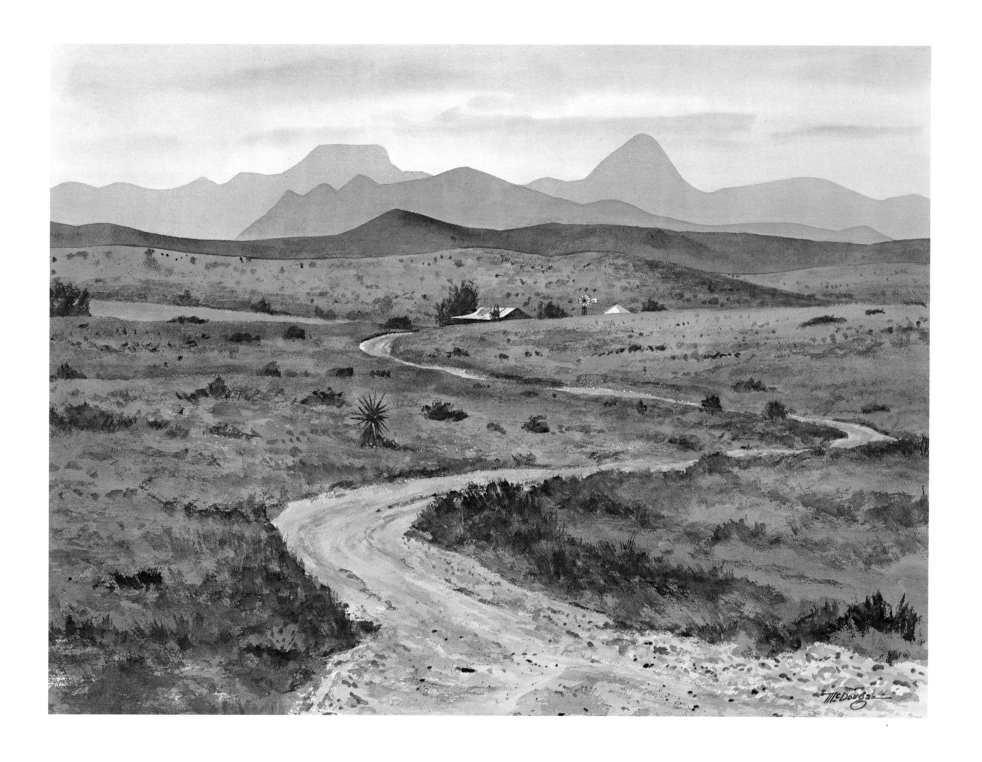

The Edge of Eternity

"The Edge of Eternity" was painted in two stages. It started as a painting of the Davis Mountains in West Texas. Now, the Rockies have such a mass that you can't comprehend it, but the Davis Mountains are not so large that you can't cope with it. They appeared to me to be like the edge of eternity. Mountains and man can coexist; they are of a kind, unlike eternity, which we can never understand. This was a personal statement which somehow I could not get across to anyone else.

So I came to paint the second stage. This area of the West has a very young history. It basically has a cattleman's soul, which is something I know nothing of because I haven't lived it, so I couldn't paint it. Instead I enlarged upon a thought painted by Remington, which to me also gives a feeling of being on the edge of eternity.

ANCEL E. NUNN

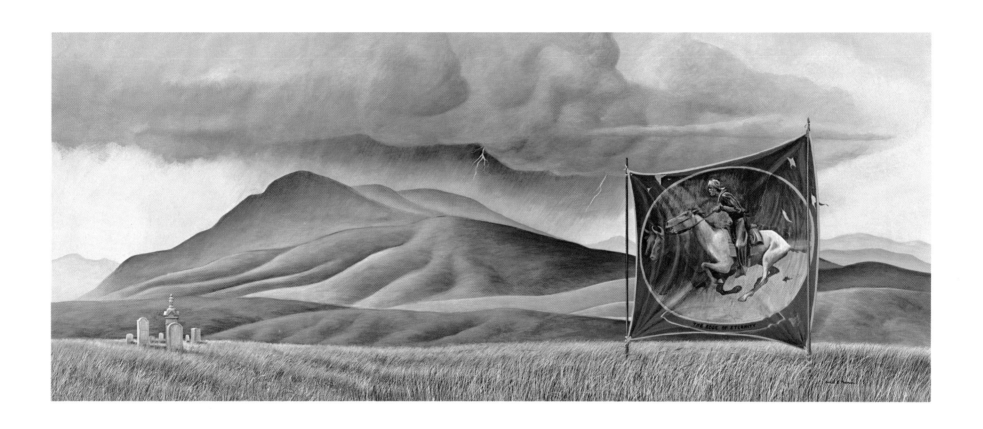

THE EDGE OF ETERNITY

Twin Peaks

This painting from highway 90 is of part of a ranch not too far
east of Marfa on the way to Alpine.

FRANK GERVASI

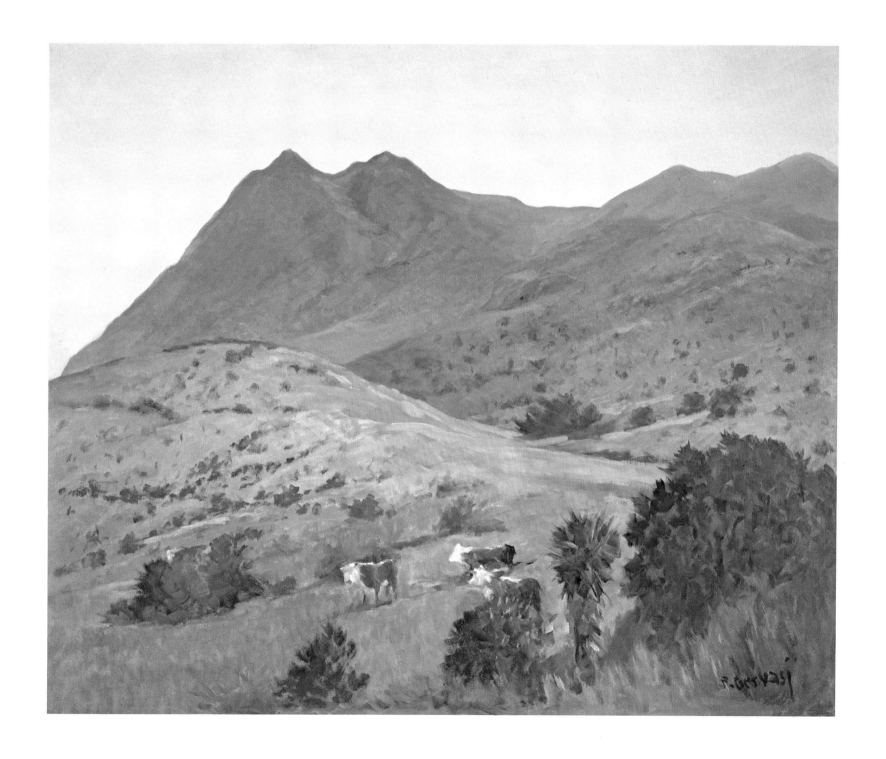

Iron Bridge over Creek

The iron bridge is a vanishing symbol of a certain time and might be seen as a kind of sculpture.

STEPHEN RASCOE

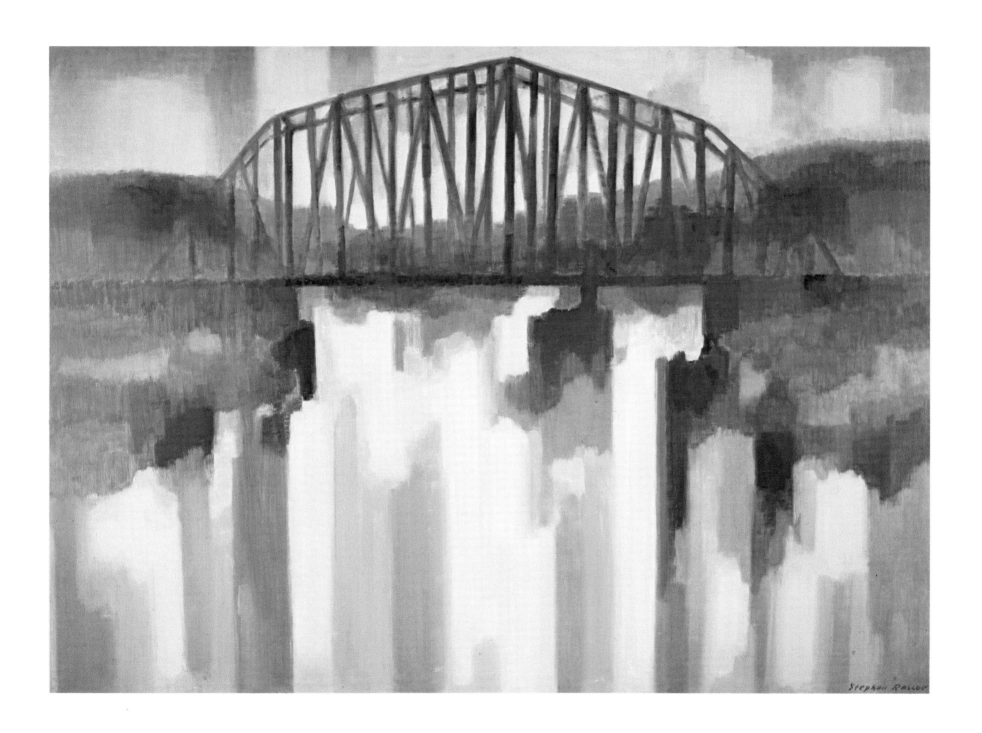

Yucca

This painting grew out of sketches of yucca plants near Alpine.

<div align="right">OTIS DOZIER</div>

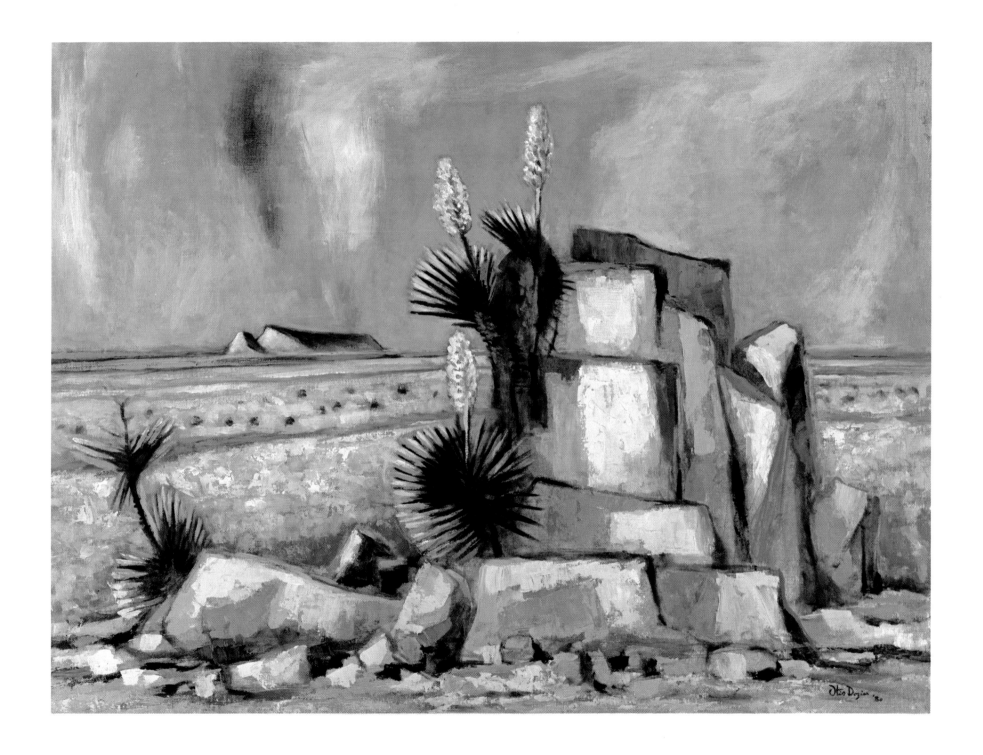

91

Canyon, Big Bend

Canyon distance can be deceptive. High bluffs and mesas rise on
either side of a meandering river. Far, far away the mountain's
muted colors shimmer in the desert heat. The viewer can be over-
whelmed by the combination of color, scale, and silence here. Man
is almost the intruder.

WILLIAM HOEY

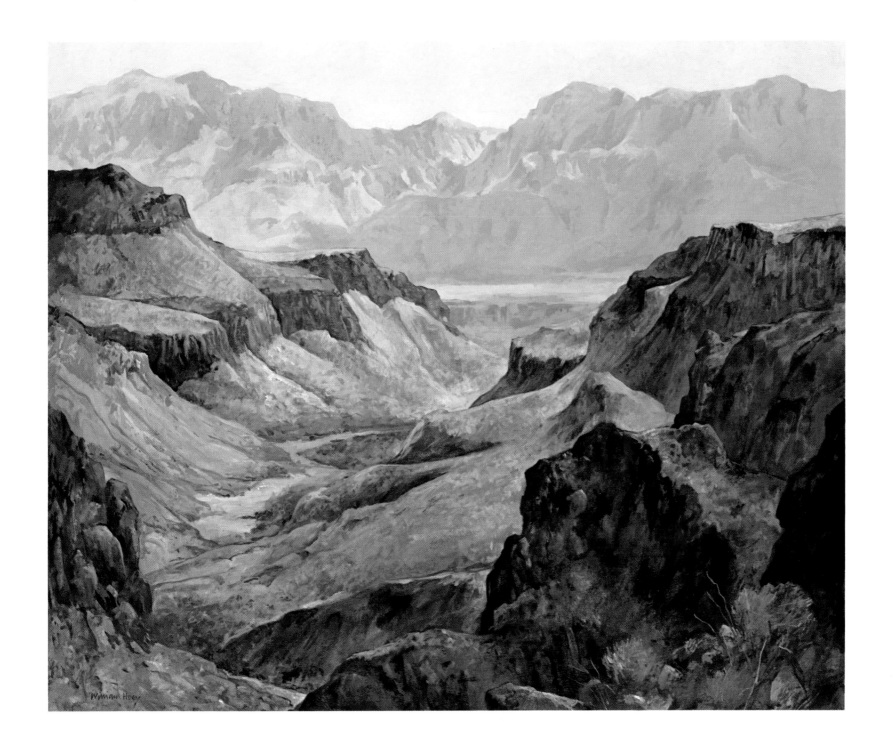

Lajitas

Lajitas is nestled among the desert mountains touching the Rio Grande. It is a water hole for those who are thirsty and a haven for those who need rest.

E. GORDON WEST

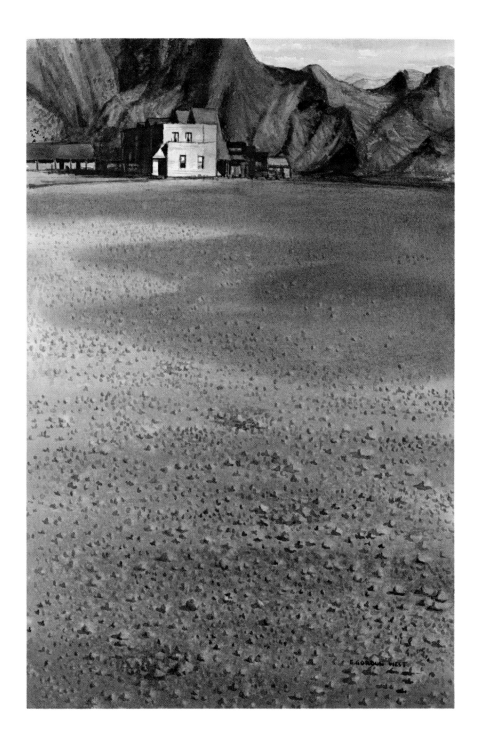

Near Fort Sumner

During many journeys through West Texas and into eastern New Mexico I have filled several sketchbooks with ink drawings, each page dotted with accurate color notes. But often I would stop briefly if the conditions made it difficult to capture color (in black ink and color notes), and I would use pastel crayons to make a "painting," as in this case where I was trying to achieve the bright colors, great distances, and unusual cloud formations. This was done in the summer of 1949, soon after I crossed the Pecos River and was moving on to the west.

JERRY BYWATERS

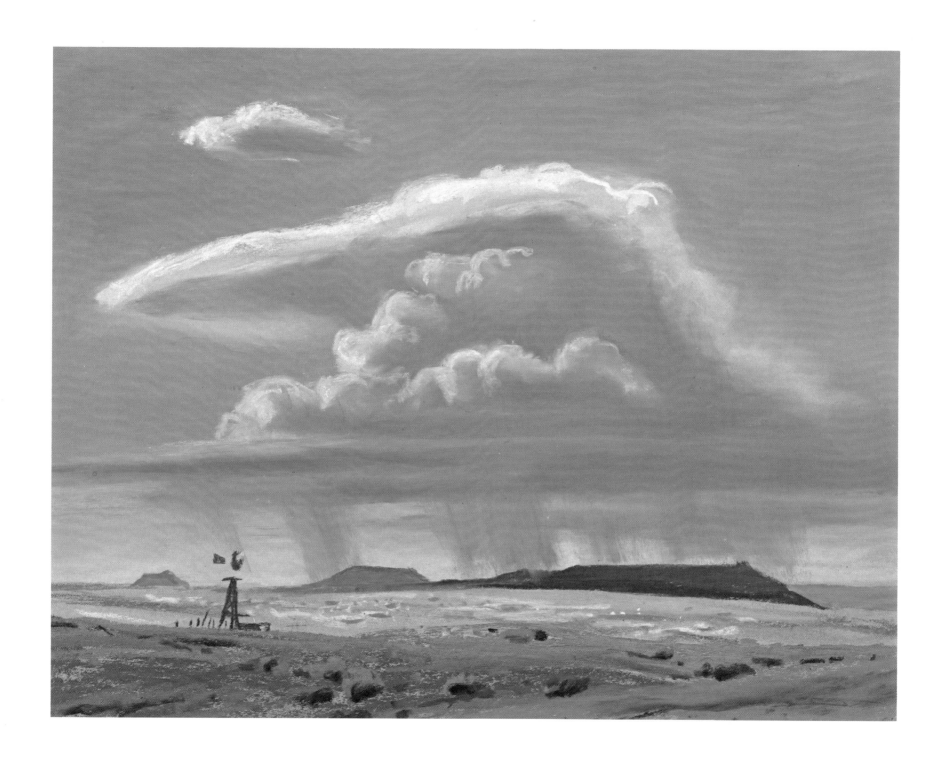

97

Flatlands—Big Bend

This is in the "Flatlands" area of Big Bend National Park. I was much impressed by the various shades of lavender and mauve. A ranger, an old-timer, was quoted as saying that "this isn't the newest or the biggest park but the wildest!"

MARBURY HILL BROWN

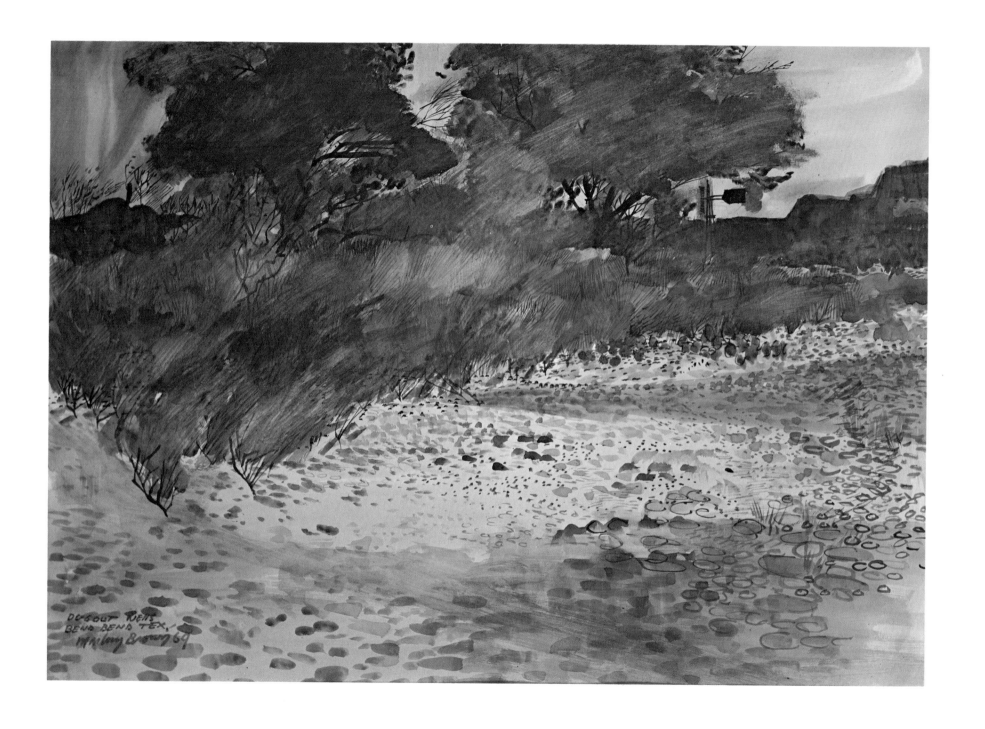

DUGOUT WELLS
BEND BEND TEX.
Henry Brown 69

Blue Rain over Canyon

This is an abstract or composite, perhaps closest to Palo Duro in West Texas. There is nothing that dramatizes the vast space in canyon country like the plane of a sheet of blue rain.

STEPHEN RASCOE

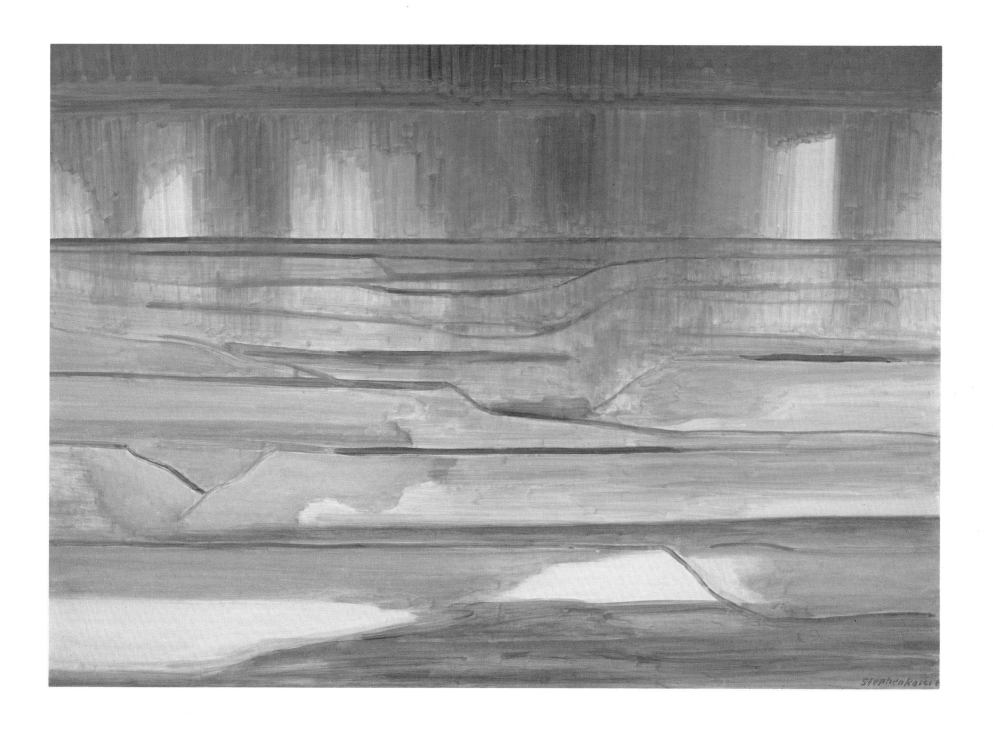

Ruins at Terlingua

Life for those who lived here long ago must have been hard. These ruins were a community surrounded by a quiet, distant beauty. The sound of voices has diminished, but the desert and the mountains remain. The evidence of a world that changed, framed by another world that seems constant, is reason enough to paint.

AL BROUILLETTE

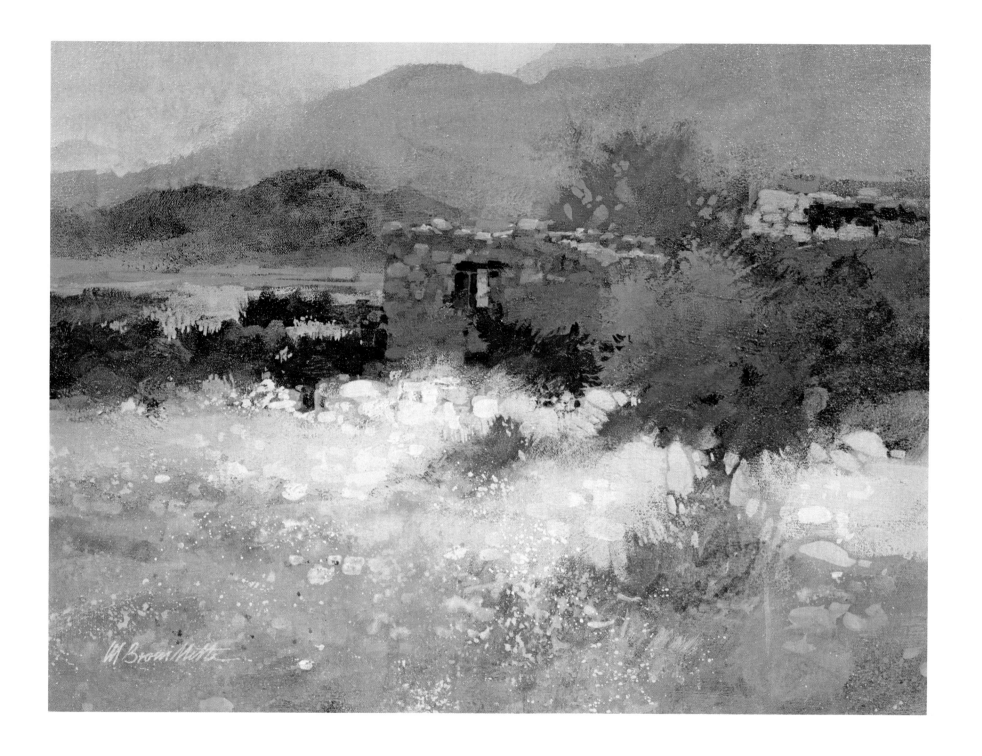

M Brown Sth

Lone Rider

The scale of the rider in relation to the rocky cliff seemed to me to emphasize the bigness and serenity of the Texas that I like.

OTIS DOZIER

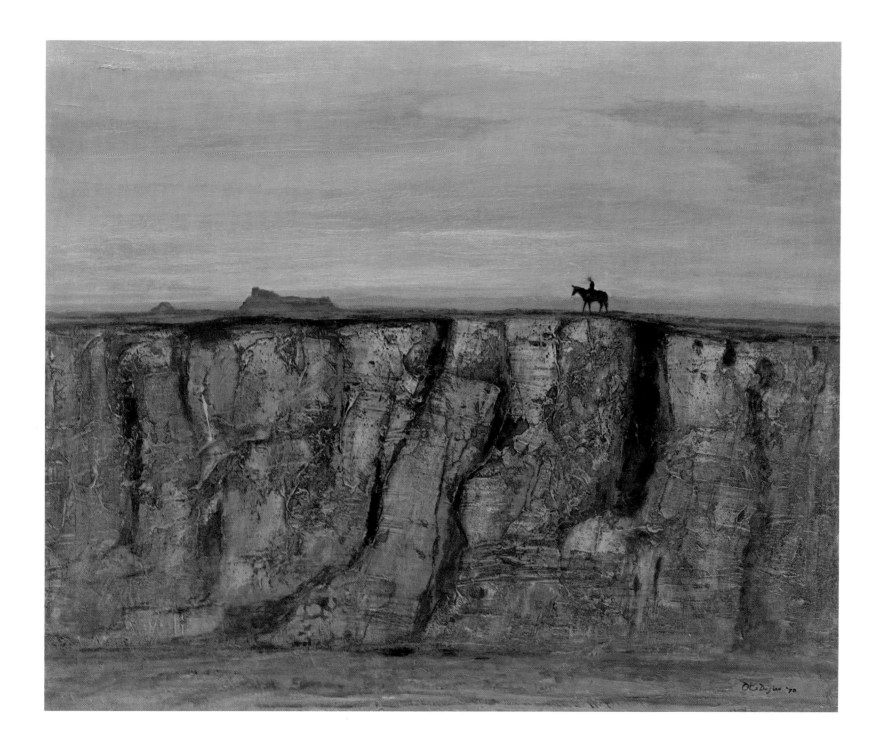

McKittrick Canyon in the
Guadalupe Mountains

There are no roads into McKittrick Canyon. Consequently on a several-mile walk the trees, flowers, and wildlife remain as they have been for thousands of years. After climbing over the boulders far back into the canyon, I began a painting. A ranger came up and asked me not to go any farther because there was a peregrine falcon nesting nearby. With this admirable concern, McKittrick Canyon should prove to be an outstanding wilderness area for some time to come. Guadalupe Mountains National Park is fairly close to Carlsbad Caverns National Park, New Mexico. All this area was once under an inland sea and has an interesting geological background.

MICHAEL FRARY

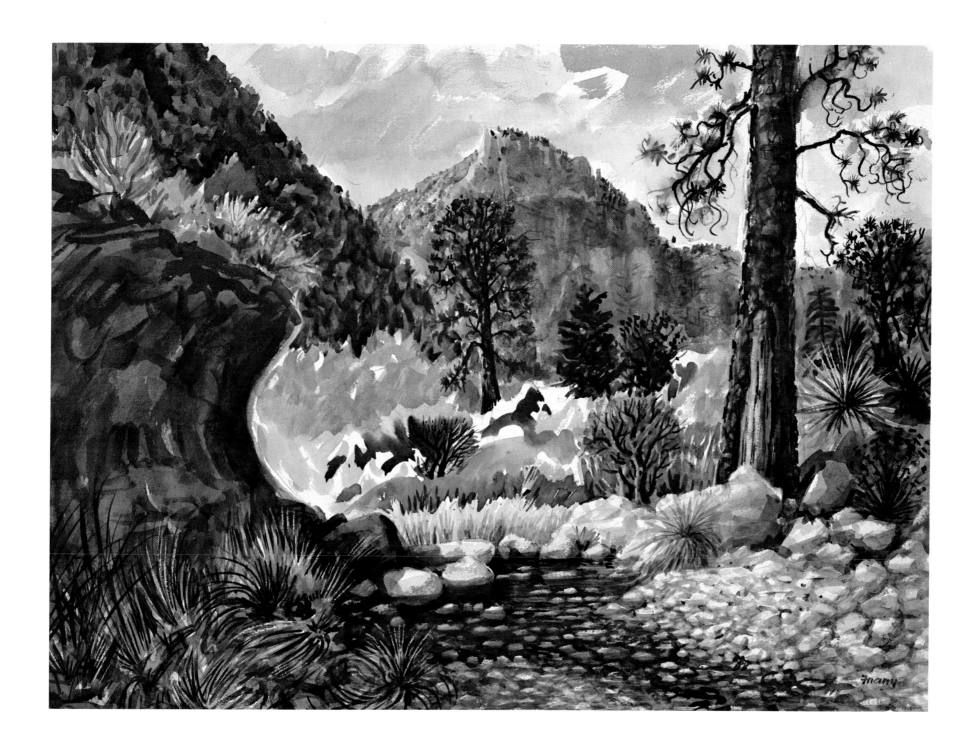

107

Apache Crossing

From the relative comfort of the back porch of the Lajitas Art Gallery, the spot from which I painted this view, I tried to imagine how the Indians must have felt as they crossed over into Mexico to steal horses from the Spanish and later the Mexicans.

IVAN MCDOUGAL

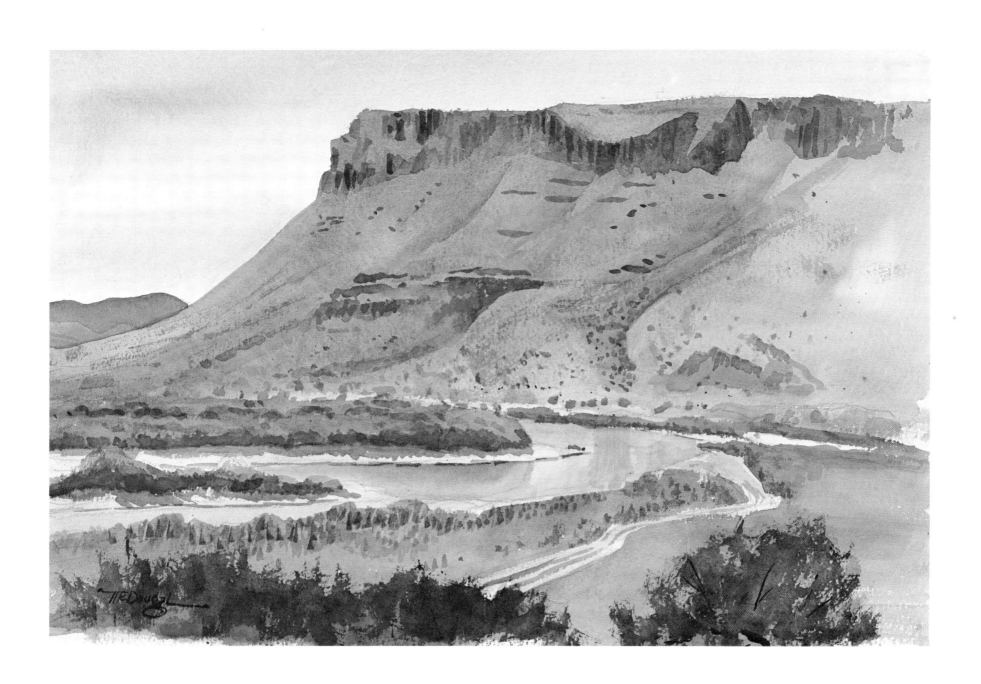

Shafter—A Quicksilver Mining Town

This view, seen by looking south of town, was painted in the late 1960s.

FRANK GERVASI

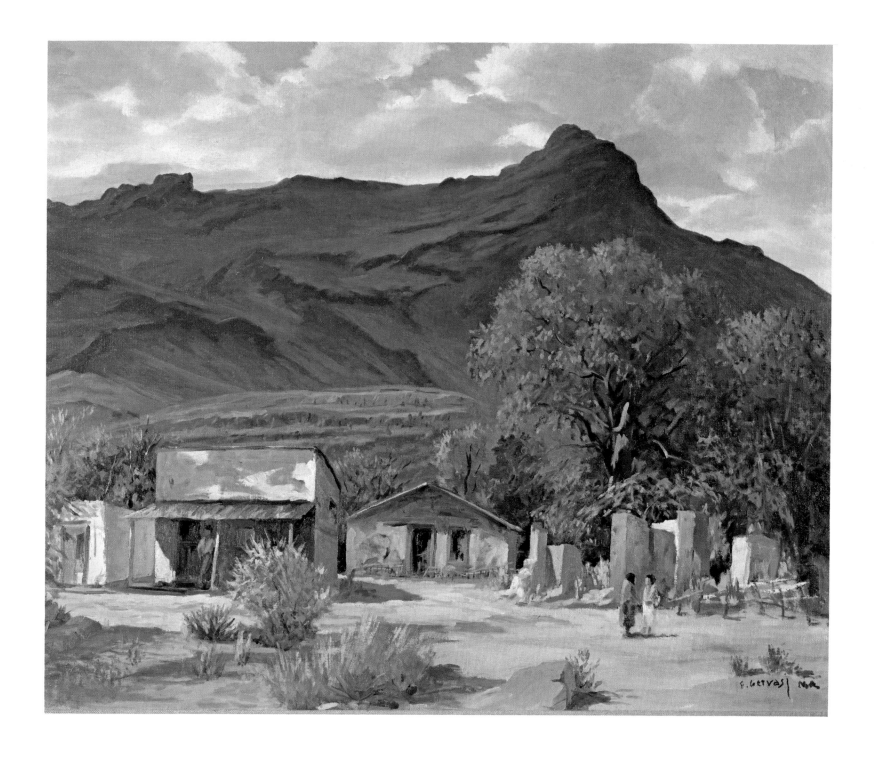

Land You Learn to Love

About halfway between Alpine and Big Bend you'll find the "Land You Learn to Love." In this small painting, I tried to express the dynamic strength of unyielding stone against the hot West Texas sky. And below, the red and green earth is being pushed this way and that. Always moving. Ever changing. I also want you to fall in love (as I did) with this wild, untamed land. Some say it's the "Land That God Forgot." But stand a moment—very still—and you will feel his presence.

FINIS F. COLLINS

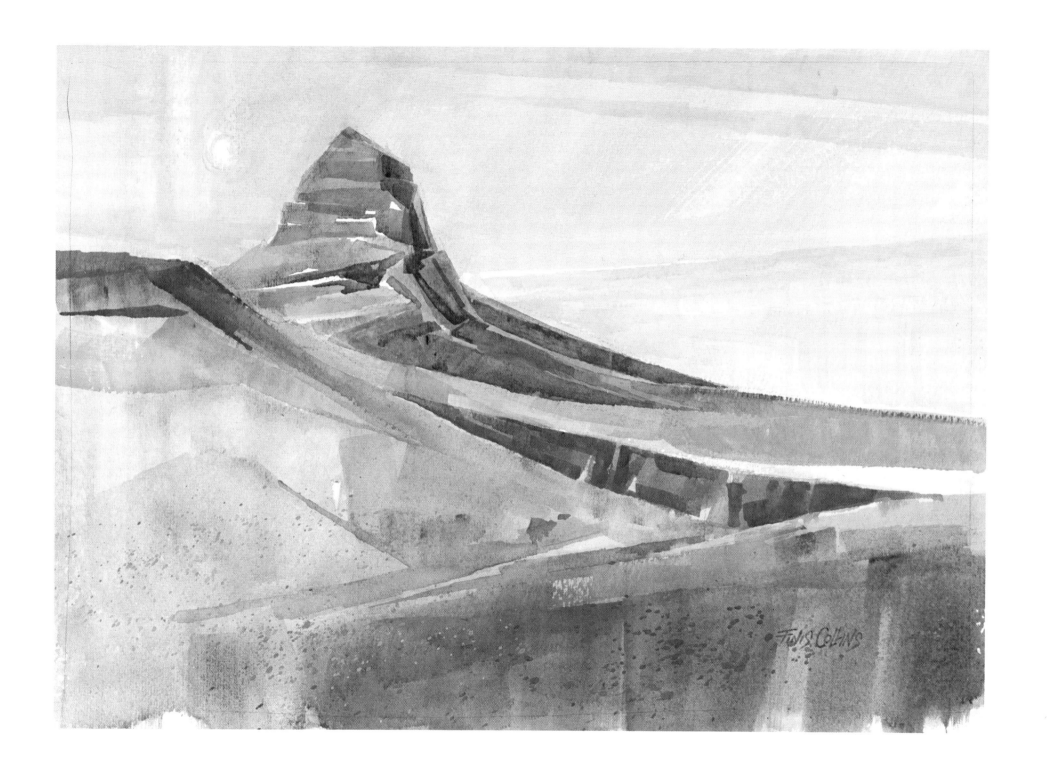

Persimmon Gap—Big Bend

This is Persimmon Gap at the Alpine entrance to the national park, as you arrive through the Chisos Mountains. This whole area of Big Bend looks as though a giant upheaval had turned the mountains upside-down.

MARBURY HILL BROWN

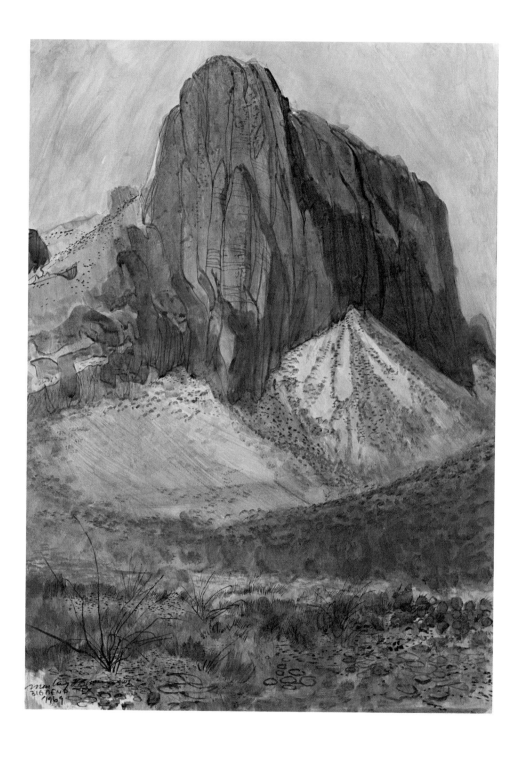

Raven

In this painting I have tried to give a feeling of the vastness of West Texas and the bright light, due to reflections of so much white rock. The raven, to me, symbolizes loneness, one bird in this vast area.

OTIS DOZIER

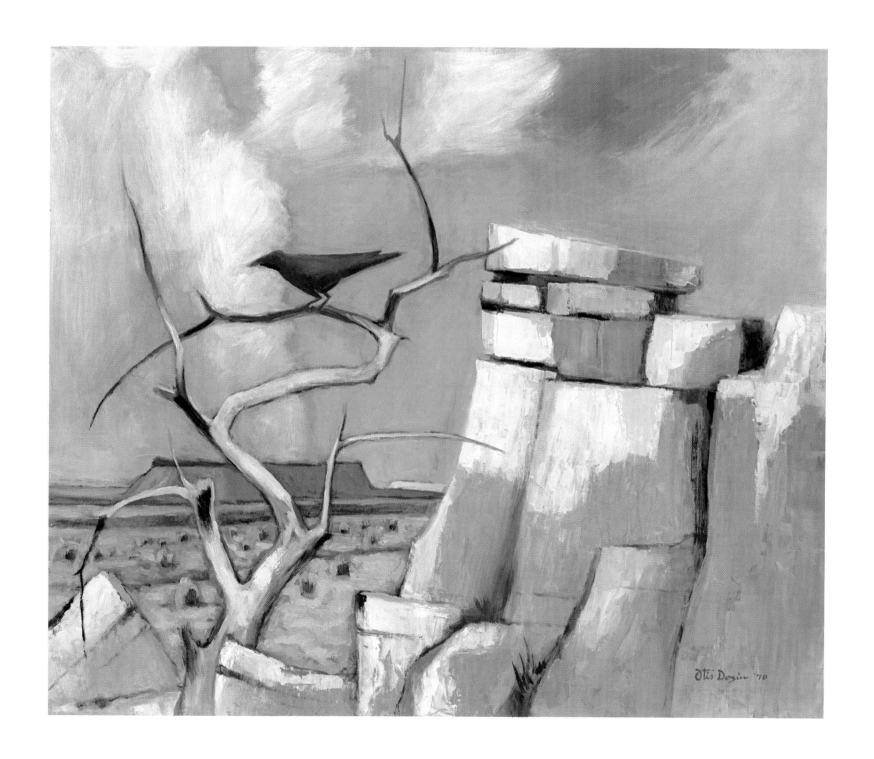

Terlingua Graveyard

In the 1930s, Terlingua, one of the few places of habitation in the Big Bend area, was little more than a store and some adobe houses scattered at random, with a small graveyard not far away. But this *camposanto* had character and color and was an inviting sight to paint, with its bright wreaths made from colored tin and bottle caps.

JERRY BYWATERS

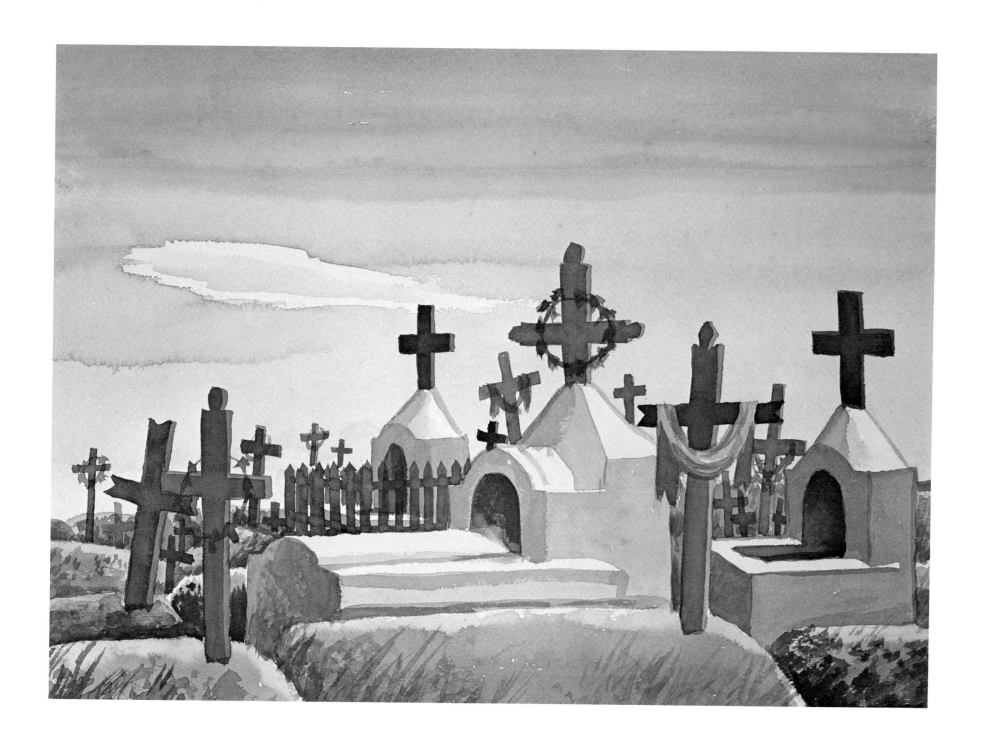

119

About the Artists

Al Brouillette has conducted painting workshops, presented slide-lecture demonstrations, and juried state and national exhibitions throughout the country. His works have received special recognition from the National Academy, American Watercolor Society, and Allied Artists of America and have been published in four books. A member of American Watercolor Society, Allied Artists of America, and National Watercolor Society, he is also listed in Who's Who in the South-Southwest and Who's Who in American Art. His studio is in Arlington, Texas.

Marbury Hill Brown studied fine art at the Kansas City Art Institute. He is a member and prize-winner of the American Watercolor Society and the Society of Illustrators in New York. He has taught at the School of Visual Arts, New York; the Pratt Institute, New York; and the Ringling School of Art, Sarasota, Florida. His work is represented in many collections, including the Dallas Museum of Fine Arts, the Houston Museum of Fine Art, and the Charles and Emma Frye Museum in Seattle. He is currently chairman of the Art Department and professor of art, Queens College, North Carolina.

Jerry Bywaters, born in Paris, Texas, received the A.B. degree from Southern Methodist University. After studying painting at the Art Students League in New York, he began a forty-one-year teaching career at SMU. From 1942 to 1963 he was director of the Dallas Museum of Fine Arts, then served as chairman of the Division of Fine Arts and director of the Pollock and University galleries at SMU's Meadows School of the Arts. Now professor emeritus of art at SMU, he is working on a wide-ranging research collection on American arts, with special emphasis on the Southwest, for the proposed Fine Arts Library.

Finis F. Collins, San Antonio, has exhibited in many museums and has been honored with shows by prominent galleries. His paintings and prints are in private collections throughout the United States. He is one of the founding members of the Watercolor Gang, former director of San Antonio School of Art, and past president of the Artist and Designers Society. For many years he has instructed art at Trinity University, the Jewish Community Center of San Antonio, and the San Antonio Art Institute.

Otis Dozier studied art with Vivian Aunspaugh in Dallas and with Boardman Robinson at the Colorado Springs Fine Arts Center, where he remained as assistant instructor in life drawing for six years. He has taught life drawing at Southern Methodist University and from 1945 until 1970 taught painting and drawing at the Dallas Museum of Fine Arts School. His work is represented in the Metropolitan Museum of Art, the Whitney Museum of American Art, five major Texas museums, and many other private and public collections. It has won numerous awards and has been shown in Texas exhibitions regularly since 1930 and in other regional and national exhibitions. His studio is in Dallas.

Heather Edwards spent her childhood in Uvalde, Texas, and completed her studies with Carl Embrey ten years ago. Her works, which have appeared in numerous exhibitions and have been represented in major galleries in Houston, Austin, San Antonio, and Washington, D.C., are included in public and private collections in America, Great Britain, and Thailand. Among other honors, she has received awards from the Texas Fine Arts Association National Exhibition and the San Antonio Art League Annual Exhibition. She currently lives in San Antonio and is preparing for both group and one-person shows.

Michael Frary received the B.Arch. and the M.F.A. in painting from the University of Southern California and did further study in Paris. He is author of *Impressions of the Big Thicket* and *Impressions of the Texas Panhandle* and a contributor to *The Texas Gulf Coast* and *The Texas Hill Country*. He has won more than 150 awards and prizes, and his paintings have appeared in more than 200 one-man shows. His work has received special recognition by the National Gallery of Art and is represented in the National Collection of the Smithsonian Institution. He is professor of art at the University of Texas at Austin.

Frank Gervasi studied at the Art Students League of New York and with such prominent artists as Frank V. DuMond, George Bridgman, and George Luks. He has won major awards for both his oil paintings and his watercolors. He is a member of the National Academy of Design, the American Watercolor Society, Allied Artists of America, Audubon Artists, and a number of other professional societies, and his works have been widely shown in their exhibitions and in many one-man shows. His studio is in Marfa, Texas.

John Guerin studied at the American Academy of Art, Chicago; Art Students League, New York; Colorado Springs Fine Arts Center; and Escuela de Bellas Artes, Mexico. His works are held in many permanent collections, including several major Texas museums, and have been exhibited at the Metropolitan Museum of Art, the Corcoran Gallery of Art, the Art Institute of Chicago, and the Whitney Museum of Fine Arts, among others. A member elect of the National Academy of Design, he is professor emeritus of art at the University of Texas at Austin.

DeForrest Judd studied art at the Cleveland Institute of Art and the Colorado Springs Fine Arts Center. His highly awarded works have been represented in exhibitions of the Metropolitan Museum of Art, the Denver Art Museum, the Cleveland Museum of Art, and the Texas Fine Arts Association. They have also appeared in many one-man shows and are included in many permanent collections. He has taught at the Dallas Museum of Fine Art and in a number of summer workshops and is professor emeritus of art at Southern Methodist University.

William Hoey received the M.F.A. from the University of Texas at Austin. Exhibitions of his work have appeared in major museums in Houston, Dallas, and Santa Fe. He has received purchase awards from the Texas Fine Arts Association and the Texas Watercolor Society, among others. Having previously served as dean of the Houston Museum of Fine Arts Alfred Glassell School of Art, he presently teaches at the University of Texas at Austin.

William Lester, born in Graham, studied and worked in Dallas until moving to Austin. One-man exhibitions of his work have appeared in New York, Mexico City, Guadalajara, and major cities in Texas. His work is represented in several Texas museums as well as the Metropolitan Museum of Art, the American Academy of Arts and Letters, and the Pennsylvania Academy of Fine Arts. He taught as guest professor at Sul Ross College in Alpine during the summers of 1949 and 1950. He is professor emeritus of art at the University of Texas at Austin.

Ivan McDougal was born in Lometa, Texas, and studied art at Trinity University and the American Academy of Art in Chicago. He has exhibited in many major regional and national shows and has received numerous awards. In 1978 he was artist of the year of the San Antonio Art League. He is represented in the permanent collection of the McNay Art Museum, San Antonio. He teaches watercolor painting at the Jewish Community Center in San Antonio and conducts occasional watercolor workshops.

Ancel E. Nunn, a native of Seymour, Texas, has received a number of awards, including the Texas Arts Alliance award and the Chicago '76 Certificate of Excellence. His work has been widely exhibited and has appeared in numerous publications. It has been featured in two films produced for television, one for the Public Broadcasting System by the Institute of Texan Cultures. His paintings are represented in many Texas museums and have been widely exhibited. His studio is in Palestine, Texas.

Clay McGaughy is a San Antonio artist who received his art degree from the University of Texas. His work is shown in galleries throughout the nation, and limited-edition prints of twenty-five of his paintings have been published. He is a member of several art societies and teaches a course in watercolor at the Hill Country Arts Foundation. He has been featured in *Southwest Art* and has done covers and illustrations for other magazines.

Stephen Rascoe was born in Uvalde and grew up in Corpus Christi. He was trained at the University of Texas at Austin and the Art Institute of Chicago. His paintings are included in many museum and corporate collections. While he has traveled extensively in Mexico and Europe, he is partial to the aerial landscapes he remembers from flying over many of the canyons and mountains of the American West. He teaches at the University of Texas at Arlington.

Everett Spruce studied with Olin Travis and Thomas Snell. He has held twenty-eight one-man shows, five in New York. His work is in the collection of the Metropolitan Museum of Art; Whitney Museum of American Art; Museum of Modern Art; Museu de Arte Moderna, Rio de Janeiro; and five Texas museums. He was awarded a Ford Foundation grant in 1959, and his work was the subject of volume I of the Blaffer Series of Southwestern Art. He is professor emeritus of art, University of Texas at Austin.

E. Gordon West received his B.S. degree from the University of Louisville and has studied at the Chicago Art Institute. His work has received numerous awards, including the O. George Pinca award in the Texas Watercolor Exhibition. He is listed in *Who's Who in American Art* and contributed to *The Texas Hill Country*. He is represented by Odyssey Galleries and the Sol del Rio Gallery in San Antonio and the Wooden Star in Houston.